fashion icon
NINO CERRUTI

teNeues

CINDI COOK

fashion icon
NINO CERRUTI

teNeues

*In memoriam
Nino Cerruti*

1930 – 2022

Contents

8	Preface, Cindi Cook
10	Letter to My Father, Julian Cerruti
14	Foreword, Jason Basmajian
21	**LIFE**
27	A Creative Soul From the Start
38	Italian Roots, An International Perspective
59	**CREATIVITY**
74	Family Business
90	A Woman's Touch
94	Completing the Picture
102	The Age of Excess
110	A Return to Understated Elegance
118	And Then There Was the Yellow Sweater
121	**ESPRIT**
147	On French Shores
150	The Stuff of Legend
160	Racing Days
167	**LEGACY**
188	Biography and Acknowledgements
190	Photo Credits

Preface

Fashion superstars like Nino Cerruti come along once in a generation. How to sum up their life, and especially that of one of the giants? This is the question that compelled me to write a book on Nino Cerruti. Considered by those in the industry as the master of textiles and fine fabrics, and, in turn, of the foundation of great Italian fashion, Cerruti stepped into the world of design in the Fifties, when it was starting to change, then did so rapidly, but was still holding fast to traditions of the past and to practices that worked. He knew that good construction of a garment was key, that what lasts is what people keep. In a time when fast fashion was closing in quickly, the designer wanted to make clothes in line with the times but that also held their own. Albeit steeped in tradition, Cerruti was a thoroughly modern man.

Even though I grew up in the United States, I was very familiar with Cerruti 1881. His ads were plastered all over every fashion magazine in the 1980s. As a teenager, I devoured my mother's *Harpers Bazaar* and *Vogue* as soon as they landed in the mailbox. I was mesmerized by the explosion of imagery, as fashion photography moved out of the age of black and white mannequins posing for the picture and into an era where movement and action dominated the images and fashion was breaking free of many norms. Designers still showed their clothes in posed positions, but in newer and fresher modes. Models jumped for joy, dove across city streets to hail a taxi, or were shot draped across cars, in the middle of a field, in altered states, or wearing clothes that were striking (Versace), bold (Ungaro), bright (Stephen Sprouse), or even outrageous (Gaulthier). Ads, as well as editorial, were all of a sudden racier than they'd ever been. New creative forces were coming into play and pushing that proverbial envelope to new and different heights.

Cerruti's business was in full bloom in the 1980s and he had established himself as a major player. The more I read about him, the more interested I became. In speaking to the designers who worked for him, I learned that Nino Cerruti was to menswear what Yves Saint Laurent was to womenswear: The two designers transformed clothing in their separate spheres starting in the Sixties. Saint Laurent skyrocketed to fame, and became a household name; Cerruti was no less a star but maintained a more steadfast and serene approach, one that was still glamour-filled but low-key in its own right. Every season was fresh, and focused on renewing what felt right and good with each collection.

Gathering and researching the information on those collections was nothing less than a pleasure. Writing this book was an endeavour to be sure, but more so was the challenge of putting it out fairly quickly. Regardless, assembling the publication took just a few months, kicked

off by deep dives into both the cyber archives and the real ones. Two trips were taken to Biella, Italy, Msr. Cerruti's birthplace and the place of his death; his family, including his son, Julian Cerruti, maintain residences there. Julian was instrumental in the making of this book and in letting this author into the warehouse that is a true treasure trove of all things Cerruti: books and books of fabric swatches dating to 1881; patterns and plans from the same era; samples of wool from years gone by, all neatly stacked in boxes; sketches and photographs from the 1960s through the 1990s, and even a few after Cerruti sold his company in 2001; and reams and reams of press clippings from every magazine and newspaper imaginable, from *L'Uomo Vogue* to *American Vogue*, from *DNR* to *Le Monde*. It was a glimpse back in time to a life well-lived, and well-preserved.

In that small warehouse were also legendary pieces of clothing that Cerruti designed over the years: racing uniforms for the Formula 1 Ferrari team he worked with from 1994 to 1996, for the team, the pit crew, and the executives. There were one-of-a-kind tops and pants, designer athletic wear from the Seventies in aqua blue, the red wool coat with black fur collar that Msr. Cerruti wore and that became his signature; and then–the pièce de résistance–a royal-purple and cherry-red silk cape done for the one and only Marlon Brando, with a matching hat. It doesn't get any better than fashion like this.

The Lanificio Fratelli Cerruti mill across the Cervo River stands as a testament to the family as well. Not a giant building yet sturdy enough, the stucco structure sits at the heart of the textile industry in Biella. The outside is graced with multiple rows of large photographs of Nino, many from his later years but of earlier times too. They capture his emotions, his wisdom, his philosophical nature, and his joy. Sadly, many of the neighbouring textile mills that once existed here have left, or have been sold to companies anxious to take advantage of their expertise. No one makes wool like the Italians, and that craftsmanship will be hard to replicate, no matter who owns the building. Many of the fabrics made here have been used over the last two centuries by the best-known names in fashion. From Saville Row to rue du Faubourg-Saint-Honoré to Seventh Avenue, Nino Cerruti continued to keep the "Made In Italy" stamp alive and well.

Grazie mille, Signore Cerruti, grazie mille!

Cindi Cook
Paris 2022

Letter to My Father

How to encapsulate the life of my father, and the legacy he left behind? Putting anyone's life into a few paragraphs is never simple, and can even be a daunting task.

The easy part with Nino? He created his legacy every day, a physical one, made out of wool and fabric and thread and color. He gave the fashion world collection after collection of the compositions that came from his head. They were concepts, whimsy, and solid ideas, all a reflection of the life he lived. It's a heritage that's hard to top. Everyone knows Nino for his classic wardrobe and for his being a tenacious businessman, as a fabric obsessive and an expert when it came to wool. He was all of that, a giant figure professionally and physically, but he was so much more complex than a facile summary can suggest. If I had to put his legacy into words, it would be this: It is one of style, elegance, humor, and good taste. He made glamour an everyday occurrence and put casual chic on the map. Why shouldn't we all dress the best we can every day? Nino had natural born elegance, a phrase I found so fitting, I used it to name a new line of clothing and accessories, which was then nurtured under Nino's tutelage. He passed on what he knew to the rest of us, and we were the lucky beneficiaries as a result. The other part of Nino's legacy: Perfection through imperfection, creating something by always leaving space for an incident or a surprise. It was a reflection of the basic human qualities he possessed, the permanent curiosity he had and interest in all things. That was the fountain of his youth. My dad was constantly following a subtle and ambiguous path to innovation, one which he felt would bring about beauty as well as quality. Mediocrity and ignorance were a scourge to him. He allowed his passion for knowledge and his profession to be his guiding principles. His was very much a contemporary dolce vita.

I became a creative person under the influence of everything around me, putting my own passion into photography and fashion. Nino's quest was always one of authenticity and originality, and felt this should be the path everyone takes, not just in fashion. He felt one should search for this always; anything less was subpar. To say I'm grateful to be Nino's son is an understatement. He taught me so much, but always left me searching for more. Maybe that was the greatest lesson of all.

Julian Cerruti
Biella 2022

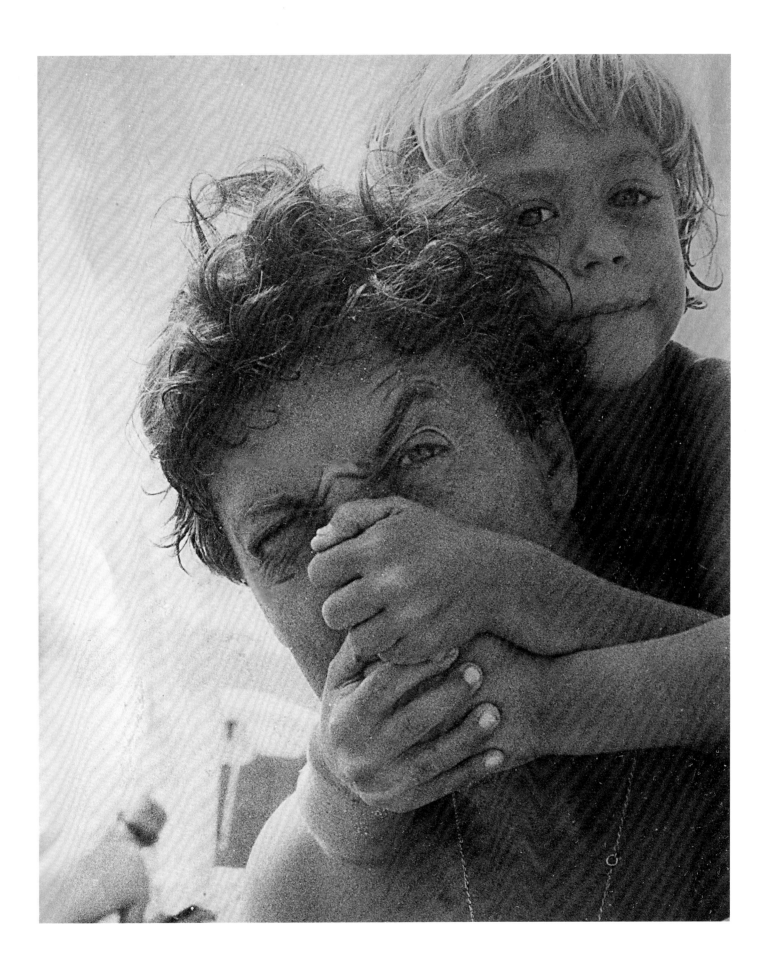

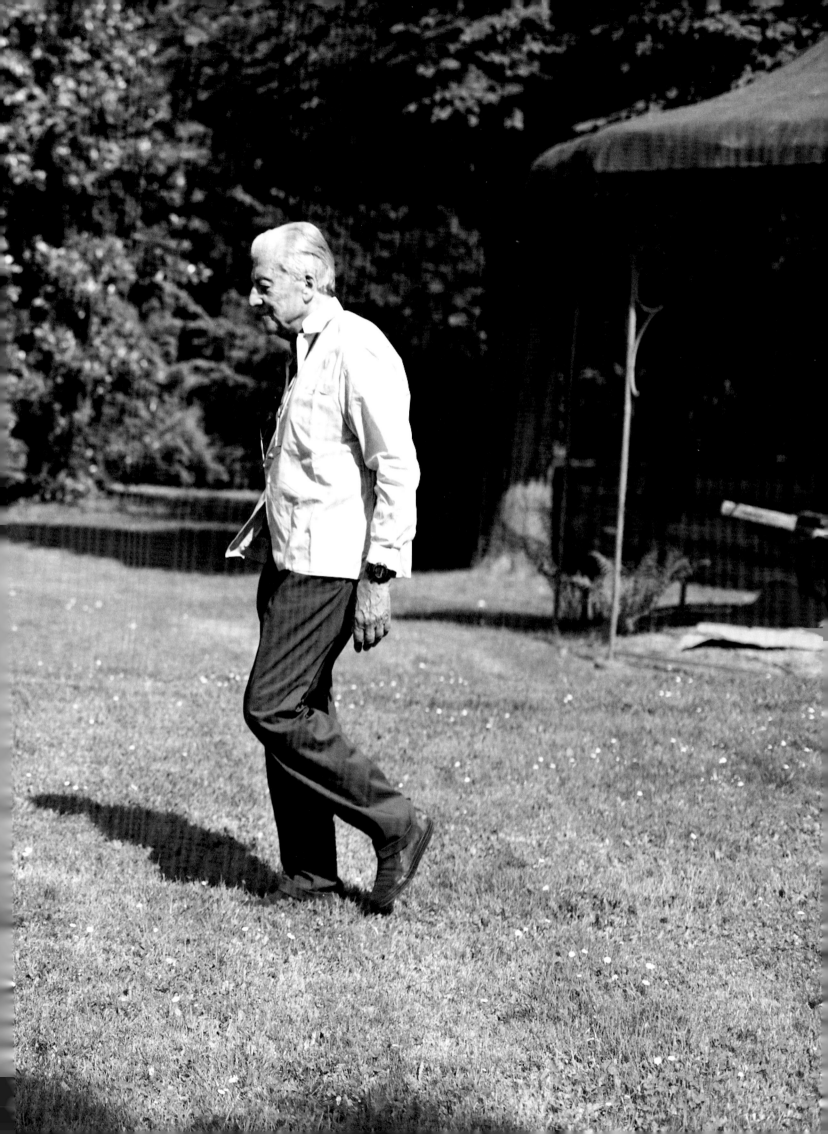

Foreword

In remembering fashion legend Nino Cerruti, the first word that comes to mind is style. Nino was a designer who understood the power of style as a philosophy. He created effortlessly chic clothes that were timeless yet ever-changing and relevant. He was both supremely confident and sincerely humble. His singular approach to fashion celebrated and empowered the wearer through his intelligence, humanism and generosity of spirit.

Nino valued quality and beauty, believing great clothing had a soul. Dressing well, to him, not only transforms the wearer but enhances the world around them. His profound impact on fashion is often overlooked as Nino built an impressive career by quietly crafting his elegance, evolving his iconic look, and living by his own rules. As a designer Nino was the first to deconstruct tailoring and obscure the lines between business wear and sportswear. He played with established codes using innovative textiles and exciting new shapes. Through his charming personality, distinct voice and old school manners Nino resonated with the worlds of Hollywood and professional sports, building meaningful relationships long before paid endorsements and social media.

Signore Nino, as he was affectionately known, was born into a family of wool fabric producers in Northern Italy. The Lanificio Cerruti Fratelli mill was founded in 1881 in Biella, an area known for the highest quality wool fabrics in the world. I first met this extraordinary man by attending fabric shows. Nino would sit with me for hours presenting the new collection explaining in detail the sophisticated colors and textures. Wool to him was a living material and he would come alive sharing his ideas of application, like a wizard willing the cloth into exquisite garments.

Many years later, when Nino no longer owned the fashion label, I was offered the job as Creative Director at Cerruti. I called Nino for his advice. He told me to start a collection designing for myself and stay the course with my vision. "Jason, make beautiful clothes and don't get distracted with the nonsense of fashion," he said. Once I asked him what makes a collection successful and he said, "I try to think in a positive way, to give people something that makes them look better and feel better. Why does everyone want to rush to be the biggest, only to move quickly on to the next thing?" This was pure Nino, the philosopher designer causing you to reflect and question.

As our relationship of Maestro and student evolved, Nino would call me before each fashion show to wish me luck. The next day he'd call with constructive feedback, his remarks always on point. He was

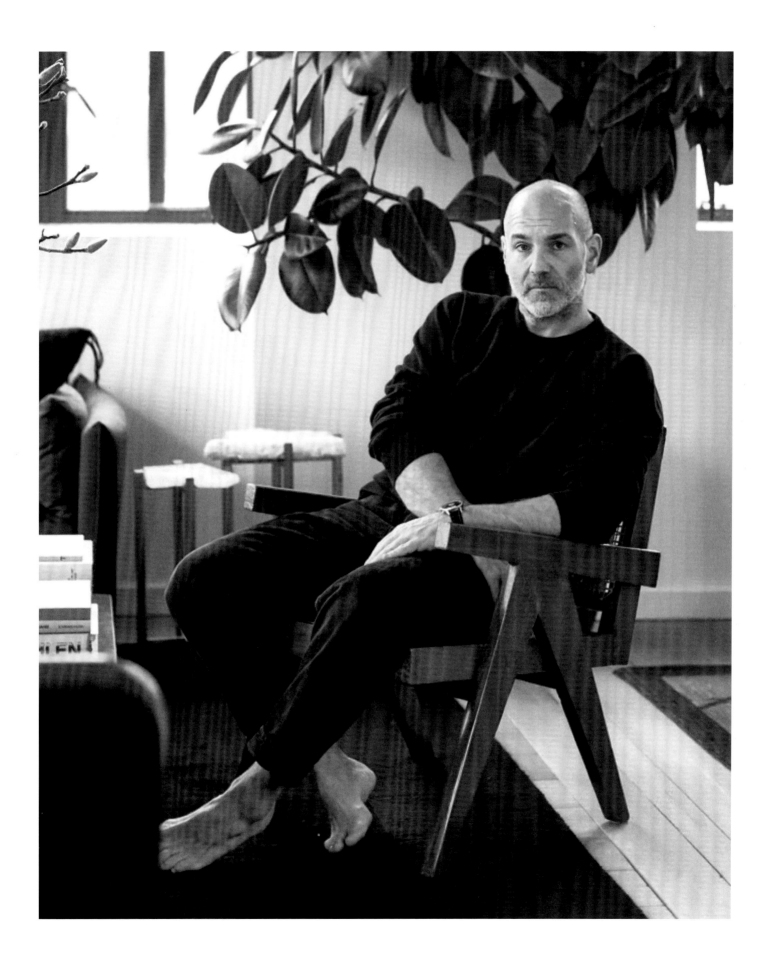

opinionated, direct, but always respectful. He was a mentor who pushed for excellence by guidance. Our conversations made me a better designer and his indomitable spirit drove me and the team forward.

Nino shared his sharp wit and infinite wisdom with everyone around him. He brought professional and personal integrity to an industry which isn't always known for kindness and generosity. While he will be remembered for some of fashion's most iconic moments, I will remember him for his warmth, passion, elegance, and profound and inimitable influence on fashion.

Jason Basmajian
London 2022

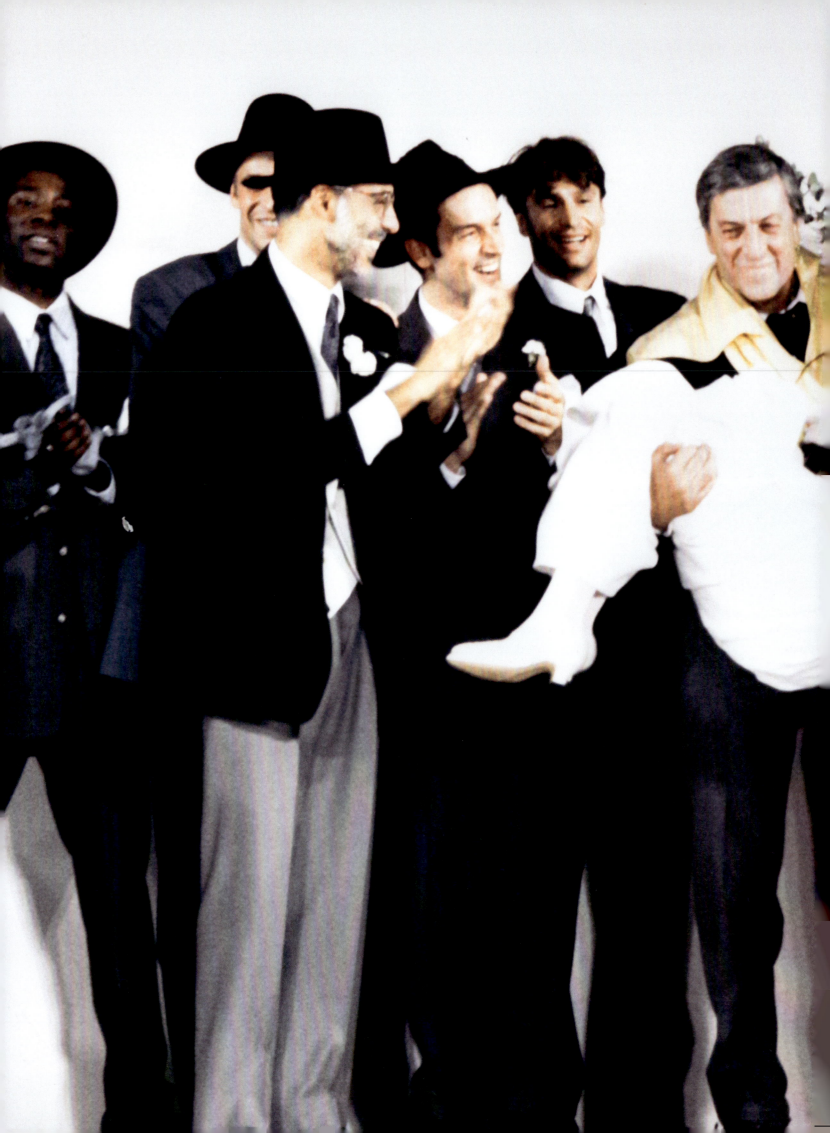

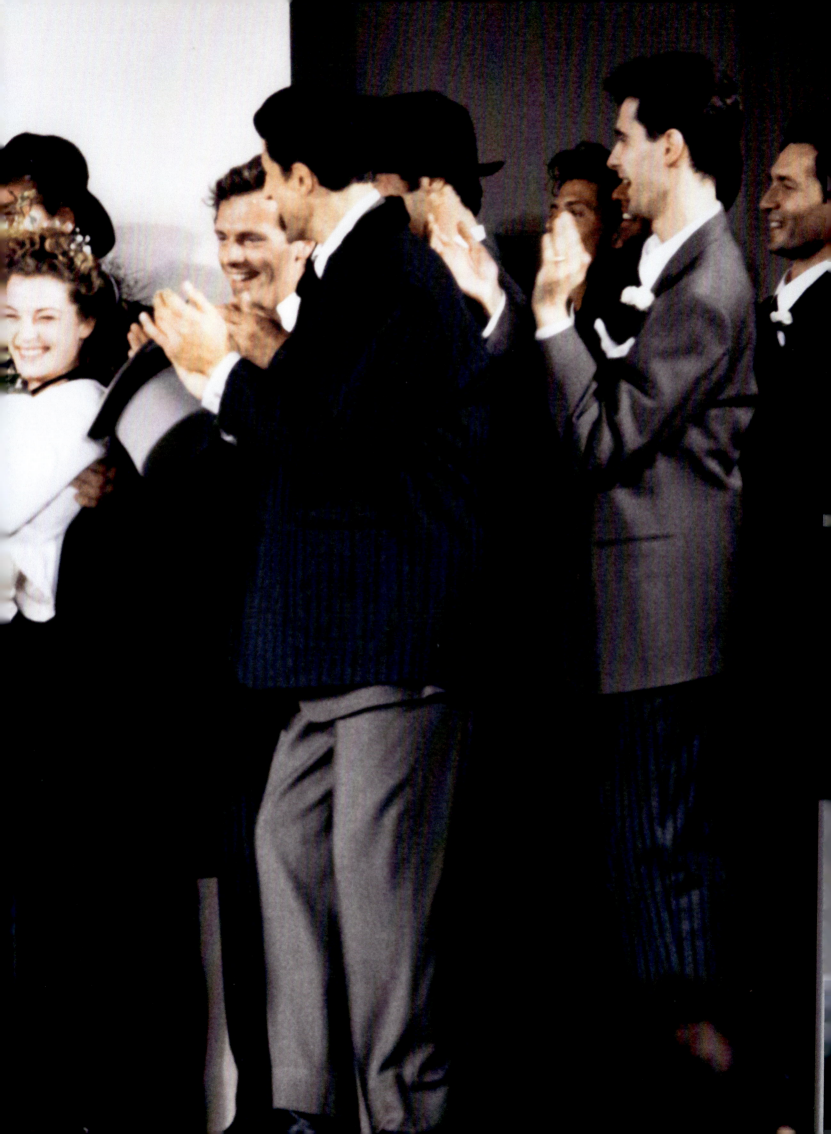

Life

He has been called the philosopher of clothing, a trendsetter, an innovator, a leading figure in menswear design of the 20th Century, and one of the founding fathers of Italian fashion. But those who knew him well merely called him Signore Nino.

Nino Cerruti was much more than the man behind his label. His work was at once bespoke, springing from a long-held tradition garnered in his native Italy, and at the same time a product of latter Twentieth Century morale, a time when clothing broke free of tradition across the board and the fashion landscape spanned as far as the eye could see. Cerruti arrived at a time and a place when ease was in and discomfort was out. The world was moving forward fast and he became the man that dressed everyone headed in that direction.

Garments were changing radically, along with what one could wear that was acceptable in public–or not. Cerruti rode the wave of the sea change that was sweeping fashion, like miniskirts, pieces considered scandalous after years of lengthy dresses and gowns that culminated in Christian Dior's full skirted "New Look" that guided women through the latter 1940s into the 1950s. Pants took on whole new forms, now becoming skin-tight, or full-blown, belled at the bottom or hugging the hip. Coats took on less and less of a shape, sacrificing fit as the body itself adopted a new freedom at the end of the Twentieth Century. A new age of apparel was dawning and the excitement was only in its nascent stages.

Although he came from a traditional background, Cerruti embraced this emerging energy as it unfolded. His life started in the northern Italian region of Piedmont, but his journey would take him to many corners of the earth, as far away as Hollywood, California and as close to home as Milan, Italy. From his days in Biella the future designer learned a trade that would last a lifetime which he shaped into more than a career: he became a true visionary. Cerruti brought forth collection after collection known as much for its verve as it was for its visual pleasure. As a man of refined taste, he was forever elegant and desired the same from his creations. Cerruti clothes were, are, and forever will be, traditional yet powerful, those that are statement–making but speak for themselves.

Cerruti created clothing that gave classic a whole new meaning; it was transformative, but reliable. It always looked right all the time. He solidified the canon yet established his own. A technician, a revolutionary stylist, and a formidable force in fashion and film, Cerruti influenced countless members of the style cognoscenti for generations to come.

Today, more than ever we need to have the courage to surprise, to relaunch our fantasy and the incredible.

Nino Cerruti

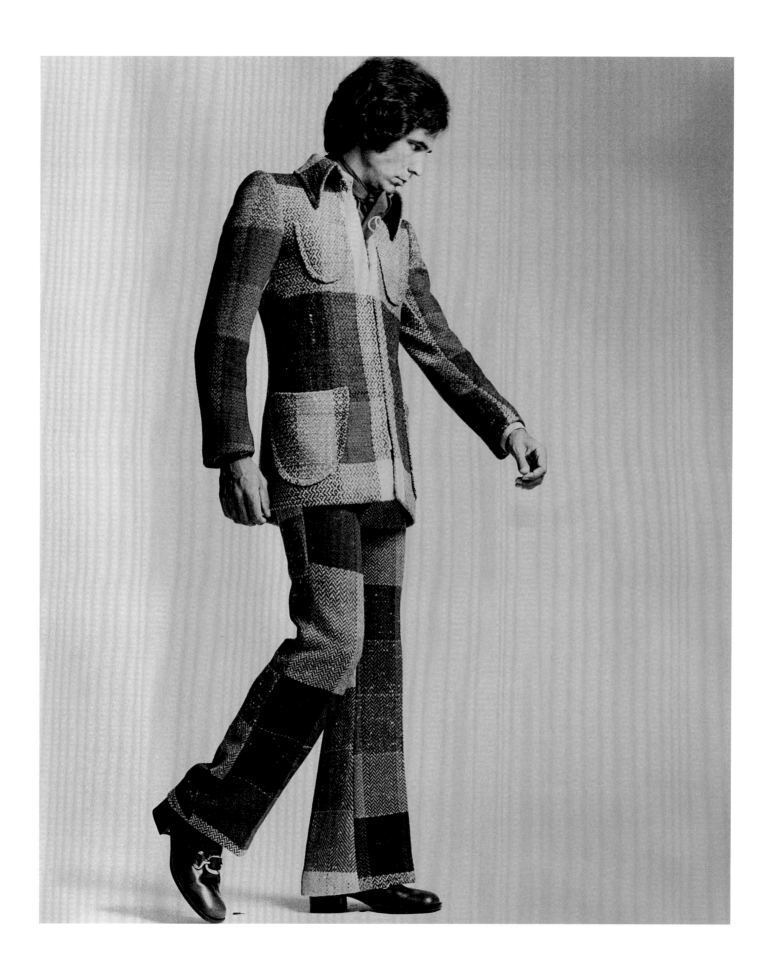

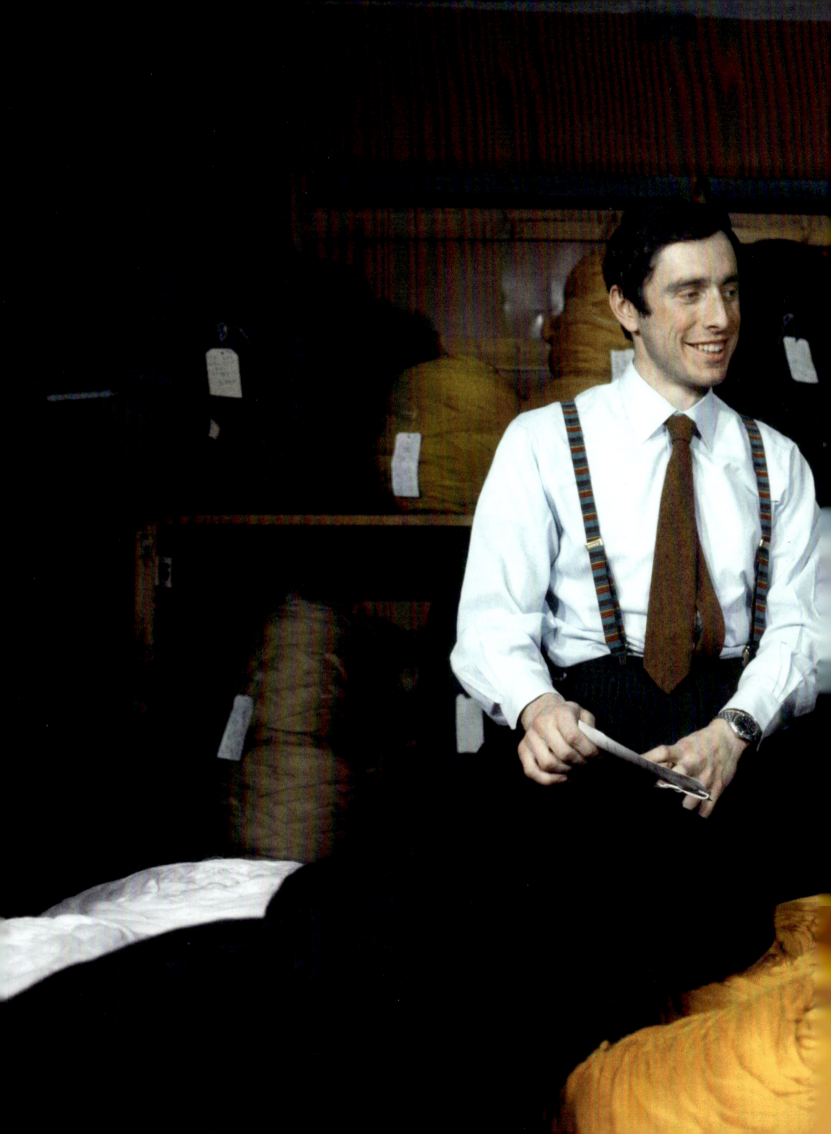

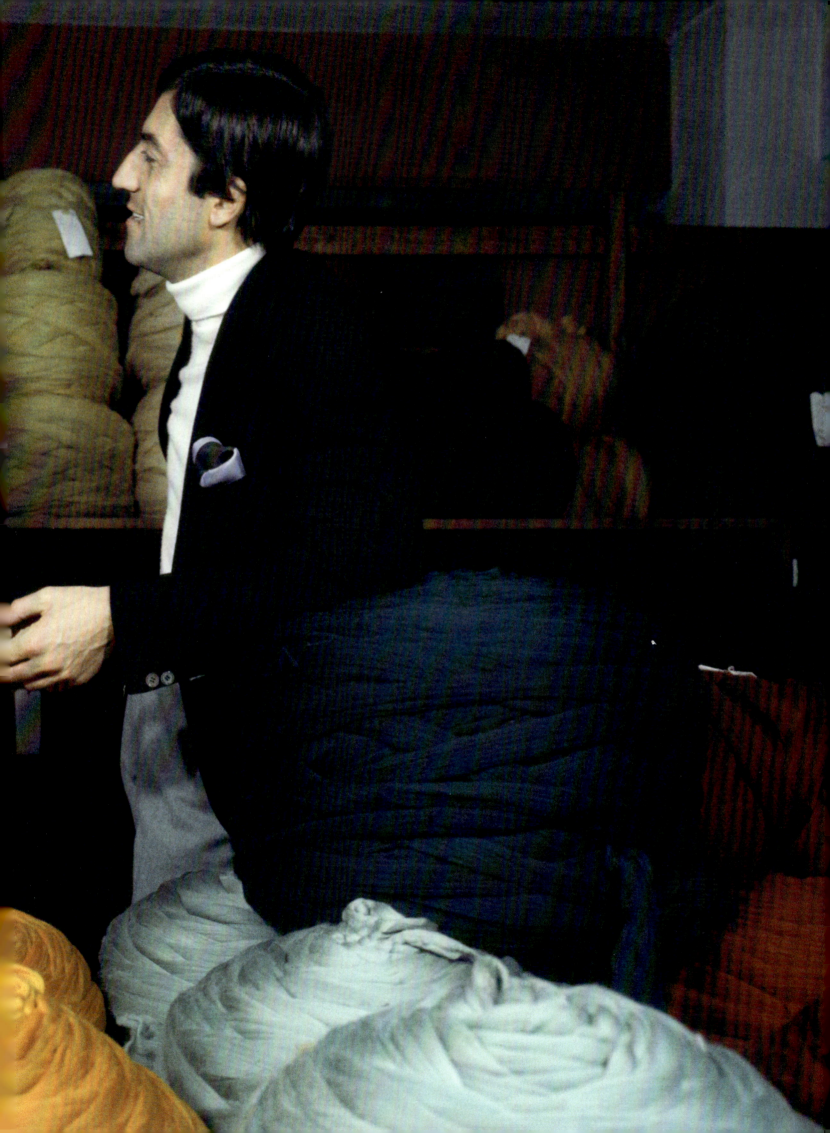

Previous page: When Cerruti took over the family business in 1950, he quickly stepped into the roles of both manager and designer, overseeing the family mill and launching a collection that would bear his name. Fabrics, though, were always at the heart of every garment.

This page: Men's suiting for the Fall/Winter 1981 Collection

Opposite page: The Cerrutis hard at work at the family mill

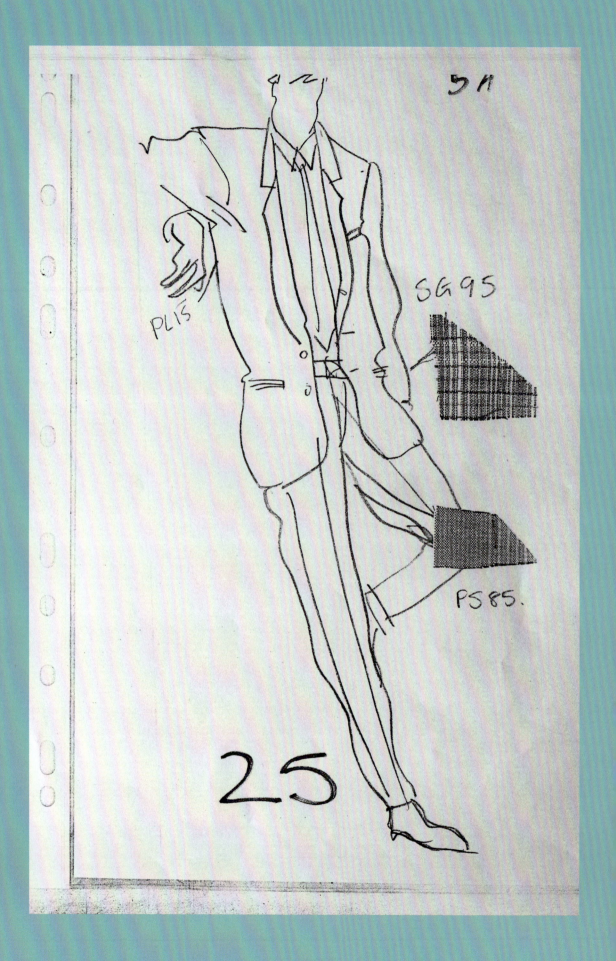

A Creative Soul From the Start

When Nino Cerruti passed away on January 15, 2022, he took with him a keen mind and a relentless work ethic–one that lasted years past the time when most people take to the easy chair and the golf links. Retirement was never in the cards for him; indeed, Cerruti seized each moment and created a life that surpassed the somewhat subdued locale where he was born. His career bridged the worlds of fashion and Hollywood, television and the catwalk. He dressed the biggest stars in the world and assembled a cadre of friends and acquaintances up and down the social and political ladder.

Cerruti had an innate sense of the body, and especially what embodied men's style. Each country–each culture–has its fashion provenance, and Italy's is borne out of an impeccable sense of presentation and propriety but also a sense of the authentic self. Cerruti's son, Julian, recognized this many times over in his father. Through it all, the fabric was everything. "No one knew fabric better than Nino," says Julian. "My father always dressed. He was traditional in that sense and enjoyed the process of wearing beautiful clothes." It was the beginning and the foundation of every garment, and Cerruti knew this inside and out.

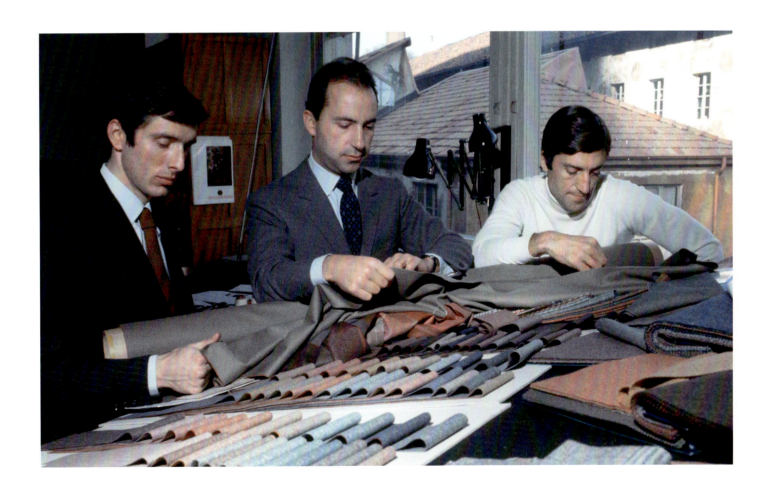

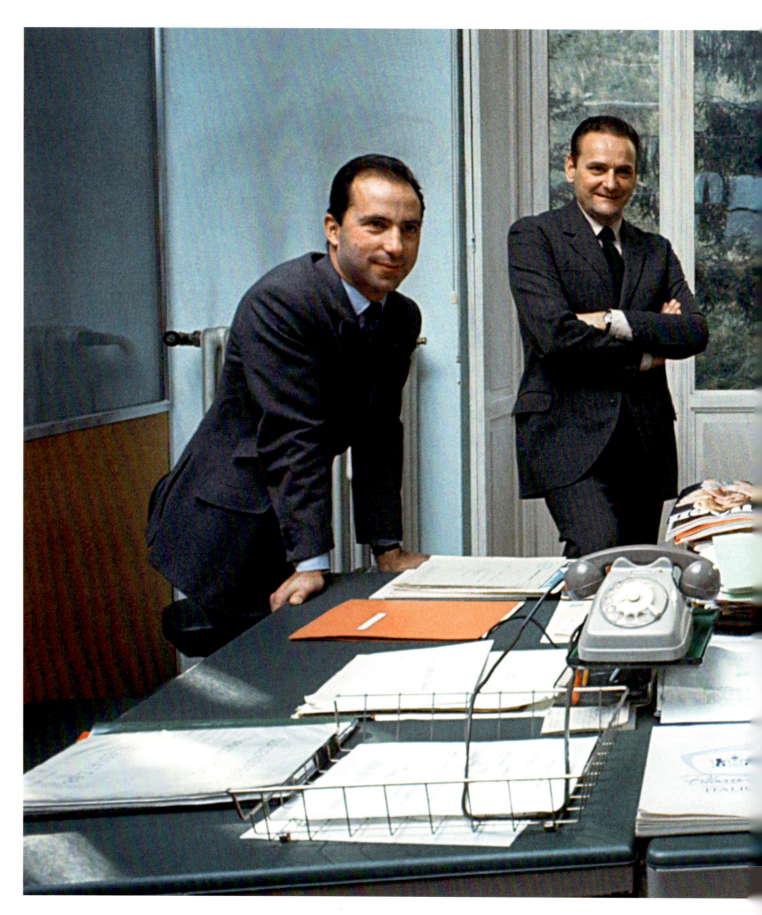

Nino Cerruti would run Lanificio Fratelli Cerruti with brothers Alberto and Attilio, continuing a family business in existence for decades. Here, they are seen in January 1968 at the offices in Biella with Export Director Dino Hafele.

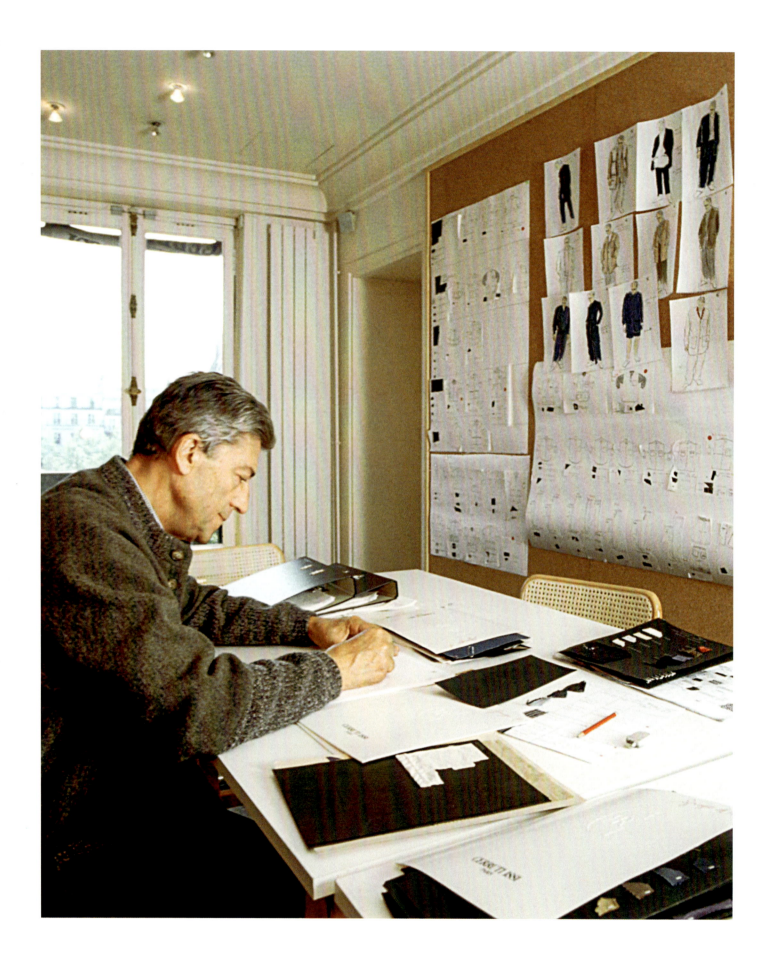

The master at work: Tireless, Nino Cerruti pored over every sketch until each collection embodied the right elements.

At right: New suiting for the Spring/Summer 1986 Collection

Following page: A sketch for the women's Spring/Summer 1972 Collection

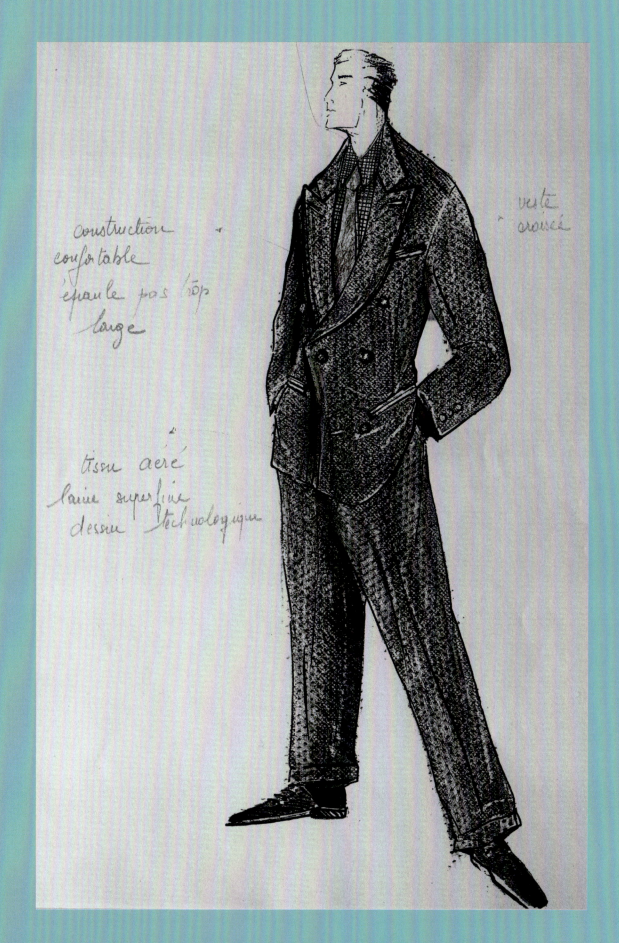

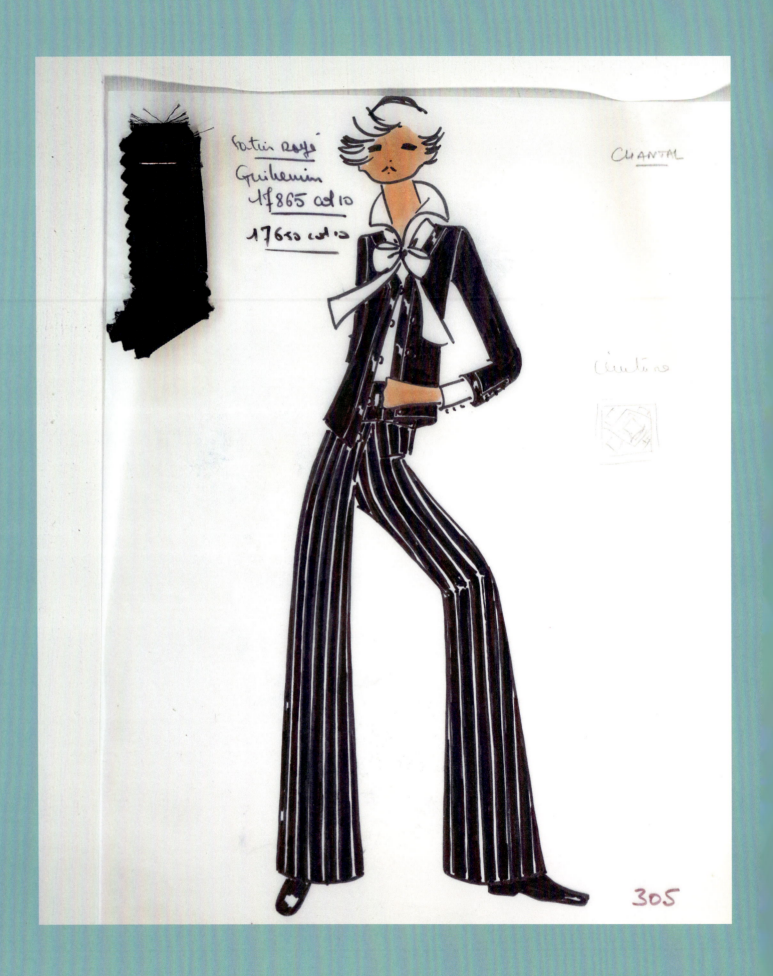

What most typifies me is a sense of continuity. My designs, albeit constantly adjusting to innovations in taste, are always developed round the same basic elements.

Nino Cerruti

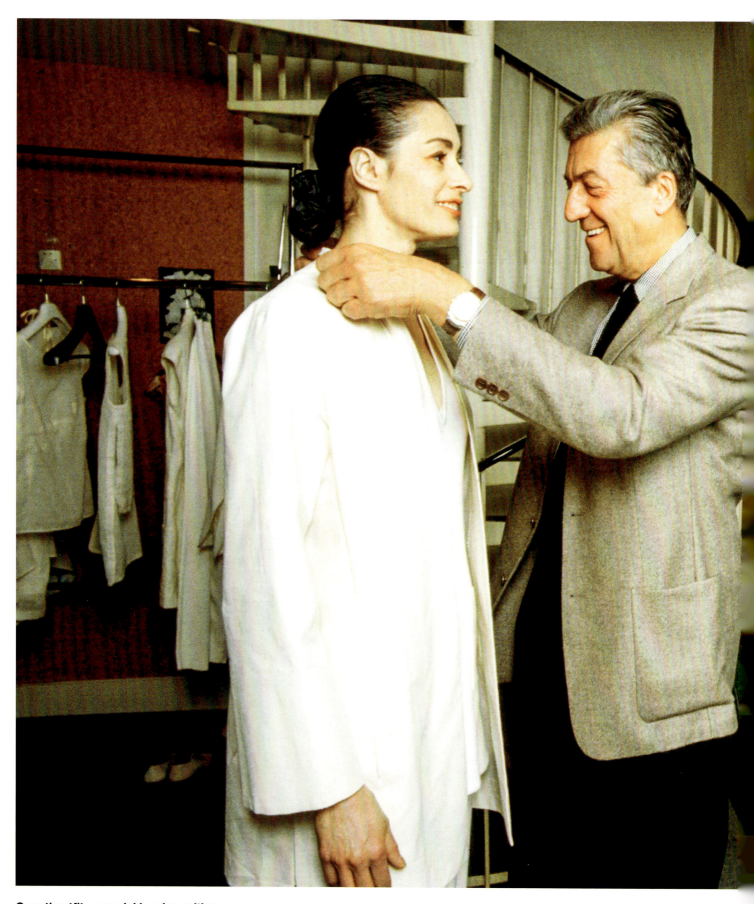

Cerruti outfits a model in crisp suiting at his atelier on the Place de la Madeleine.

Following page:
Cerruti preps men's suits before a runway show.

Italian Roots, An International Perspective

Nino Antonio Cerruti was born in Biella, Italy on September 25, 1930, the eldest of six siblings, along with brothers Attilio, Fabrizio and Alberto, and sisters Carla and Iza. His parents, Silvia Tomassini Cerruti and Silvio Cerruti, were born and raised in Biella and sought in turn to raise their family there as well. Along with the apartment they held in town, Silvio had bought a country house for his wife just outside the city center, which would serve as an escape from the industrial occupation of the family business.

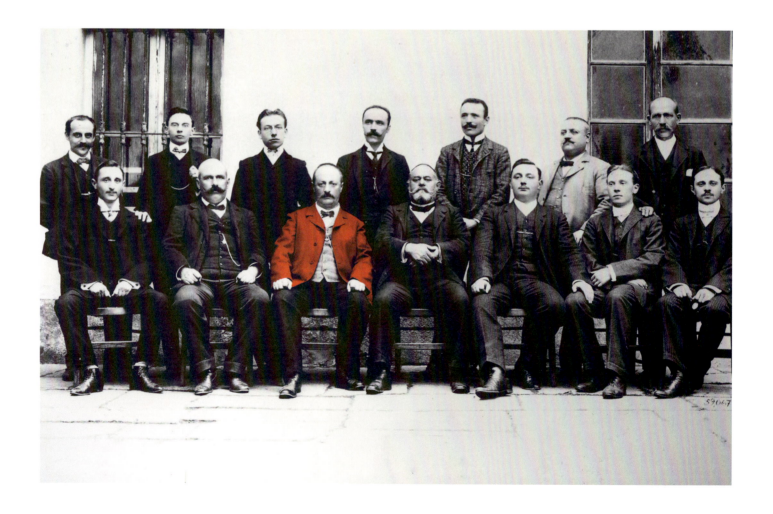

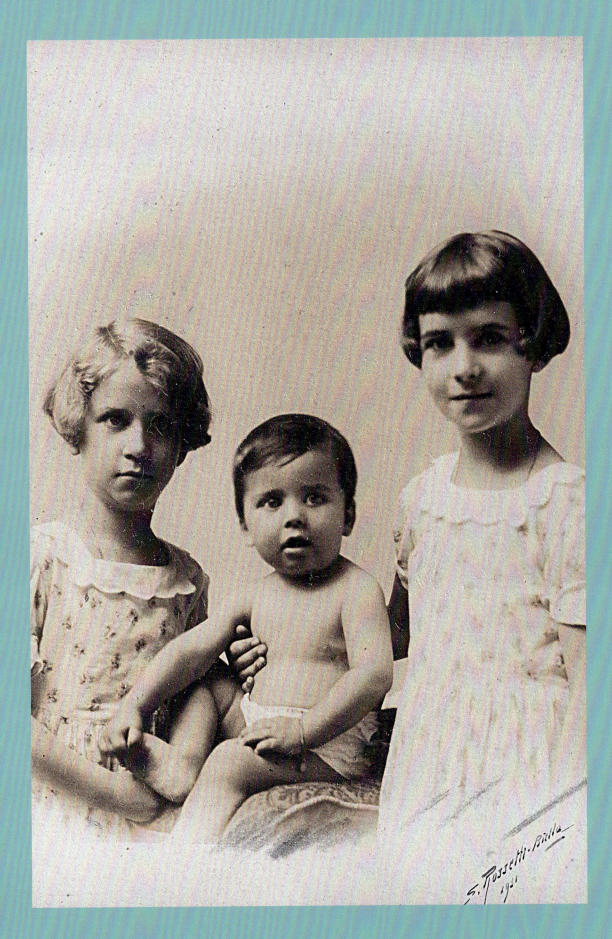

At left: Baby Nino with sisters Carla and Iza. Opposite page: Historical photo of textile workers seated outside the factory in Biella, Italy

Previous page:
Biella is nestled in the northwestern region of Piedmont, the heart of Italian textile manufacturing.

Left page:
Situated below the Pennine Alps, the town of Biella lies in one of Italy's most picturesque regions.

Right page:
Entrance to Lanificio Fratellli Cerruti, the Cerruti family mill, in Biella, Italy

Biella is nestled in the northwestern region of Piedmont and is the heart of Italian textile manufacturing. Although a city, it has the feel of a village with low long buildings and secret passages that lead to the many manufacturing facilities, some still there, some having left due to a globalization of the industry. Biella is in the lucky position of being 80 kilometers west of Milan, a center of global fashion, with the Italian Alps as its backdrop.

The route that leads from Biella to the neighboring town of Borgosesia is known as the Wool Road, a 50-kilometer stretch through which Italy's textile industry was forged. The abundant streams and lakes fed from the Alps in the distance form a picturesque landscape in the Strona Valley. Heritage, quality, and the best woolens in the world are as much a product of the region as are the natural elements therein.

Cerruti stands in front of a school dedicated by his father to the town of Biella, Italy.

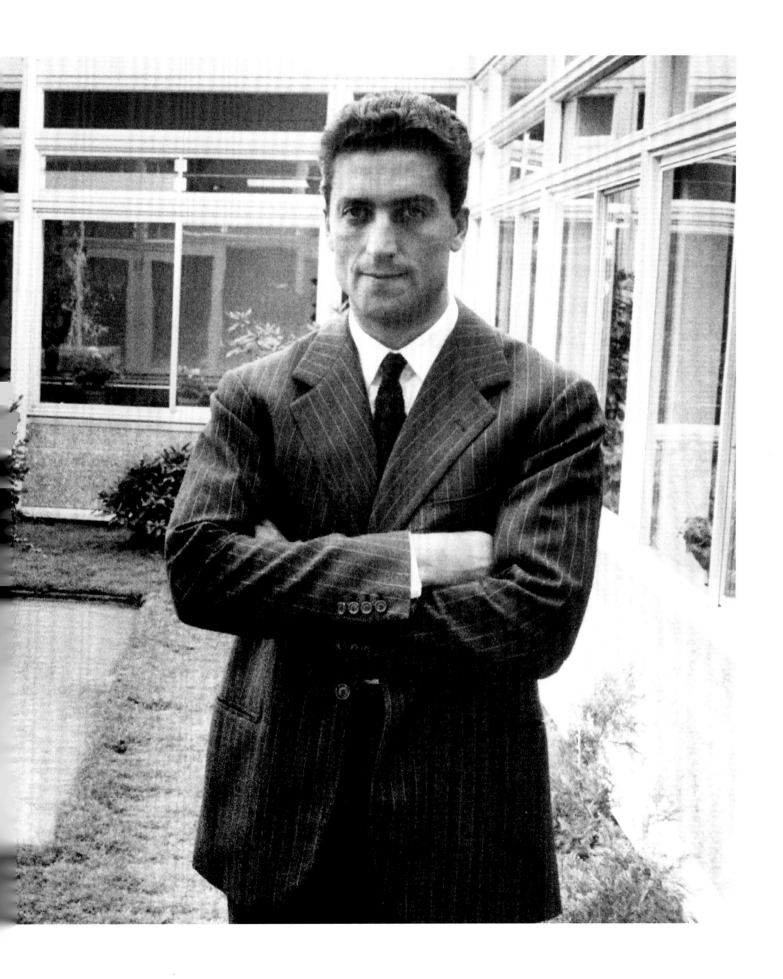

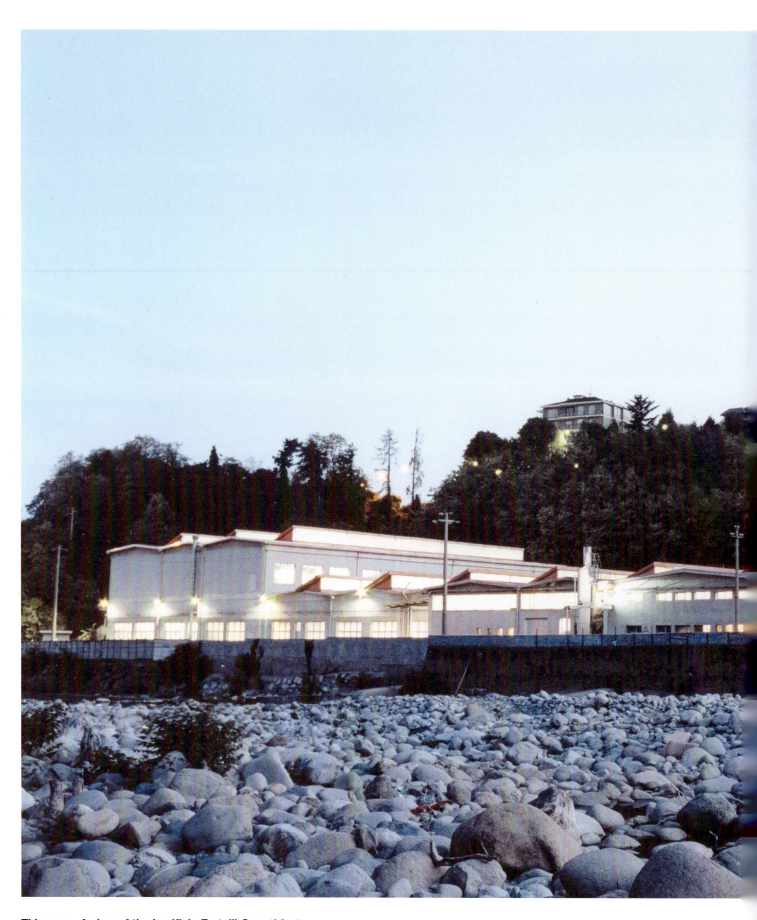

This page: A view of the Lanificio Fratelli Cerruti factory
at night from across the Cervo River in Biella
Following page: At left, the older, original part of the factory;
At right, a part of the newer area of production at Lanificio Fratelli Cerruti

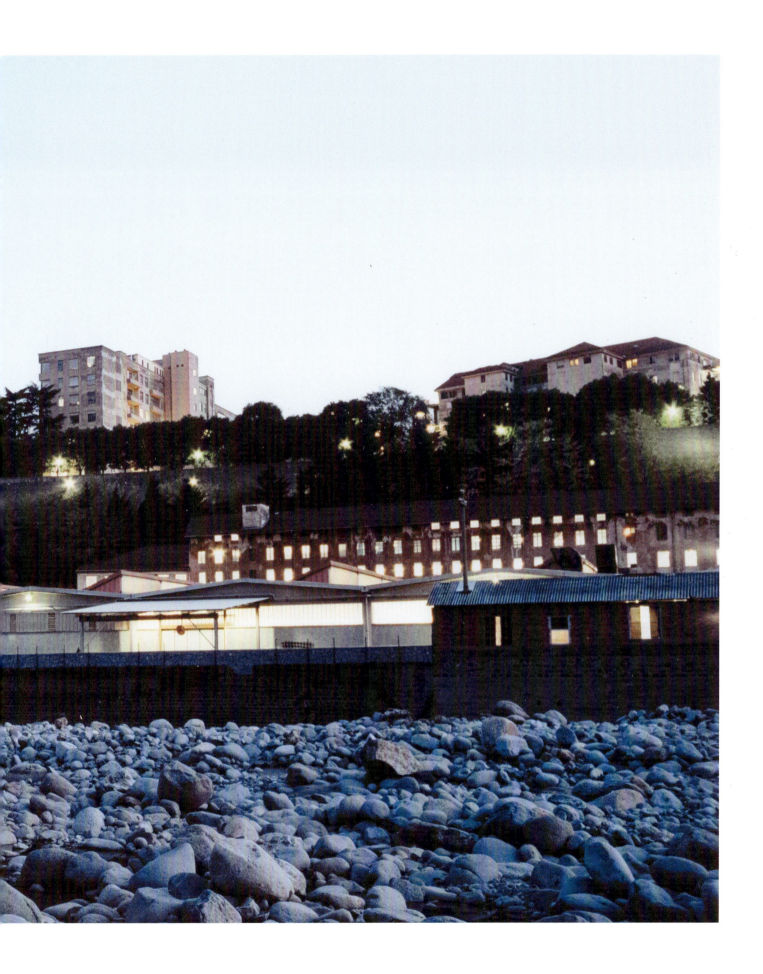

Industrious families have made this their home since the 13th Century, with the College of Weavers and Wool Merchants being mentioned in Biella's city statutes. The Cerruti family has long held a prominent place here: In the mid-1700s, the family name appeared in the communal listings for the city under the heading "Arti et Negotij"-the term for those who manufacture textiles. For the nearly two centuries that followed, the Cerrutis earned a reputation as expert weavers, working either as skilled artisans-for-hire or in private business making the cherished fabrics that emanated from the region.

Eventually they opened shop on their own: Quintino Cerruti, Nino's grandfather, founded the family textile business in Biella in 1881. It was named Lanificio Fratelli Cerruti, which translates to English as Cerruti Brothers Woolen Mill. There they spun their fibrous gold, for companies in Italy and around the world who knew the expertise of the weavers in the region. The Cerruti mill still stands, on the banks of the Cervo River.

Within the first two decades of operation, the business thrived, with product ordered by markets near and far, especially those in the United States. After the turn of the century, Lanificio Fratelli Cerruti aided the war effort in World War I: In 1917 alone, they churned out 170,000 meters of gray-green cloth for the army. By 1945, the mill employed 700 workers and held 140 looms and 7,100 spinning spindles.

In 1950, Cerruti's father, Silvio, died suddenly. As the eldest son in the family, Nino was the heir apparent. He quickly stepped up and took over the family business, at the tender age of 20. The younger Cerruti was still in college, studying philosophy and had aimed to become a journalist, but stepped into his new role swiftly and easily. Cerruti knew the business and knew how to make it work. Moreover, he had leadership qualities that naturally rose to the surface. His brothers also took key roles in the textile operation, continuing their success.

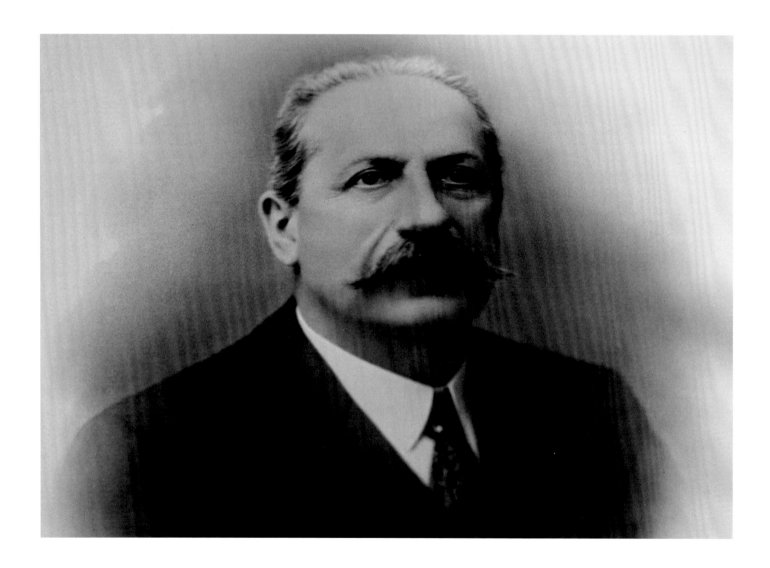

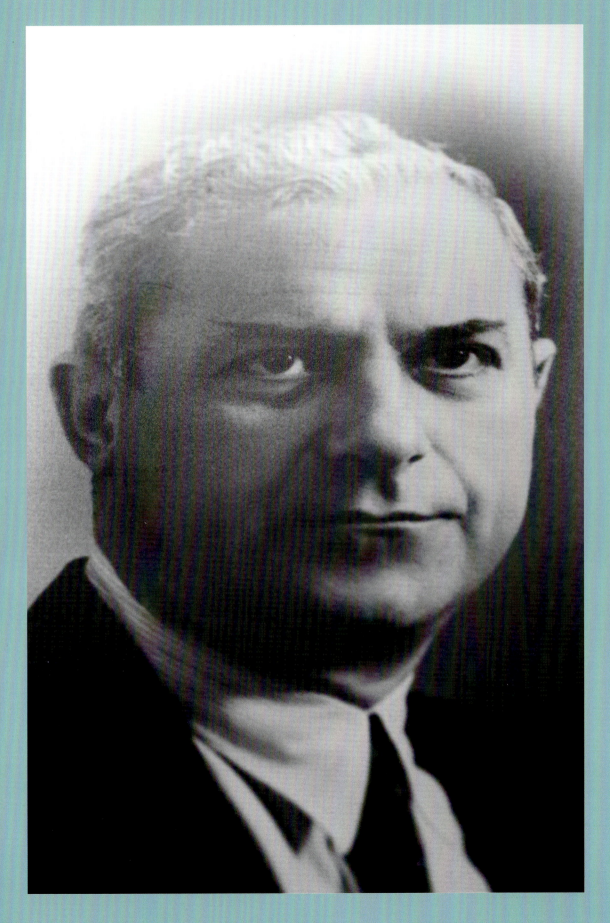

Opposite page: Quintino Cerruti, Nino's grandfather, founder of the textile mill in Biella that bears the family name. At left: Silvio Cerruti, father of Nino Cerruti, continued the business until his untimely death in 1950.

The process of dying wool at Lanificio Fratelli Cerruti

Previous page: Wool flocks being threaded in the mill and various balls containing different flocks of wool in different colors and tones awaiting threading

The finishing stage of a fabric being washed

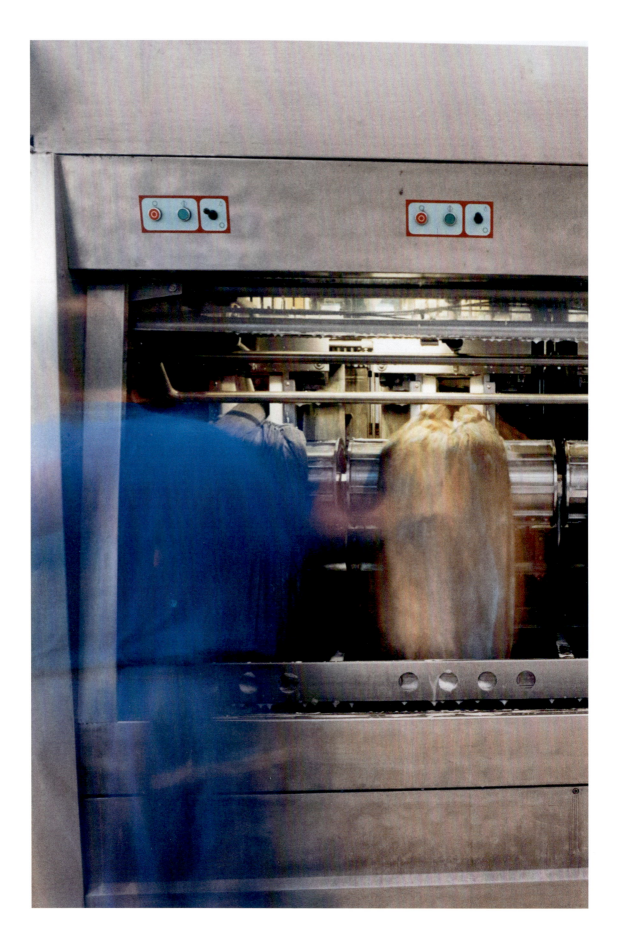

Top:
The final product,
bails of Cerruti wool

Bottom:
Two workers setting
the machinery on the
factory floor at
Lanificio Fratelli Cerruti

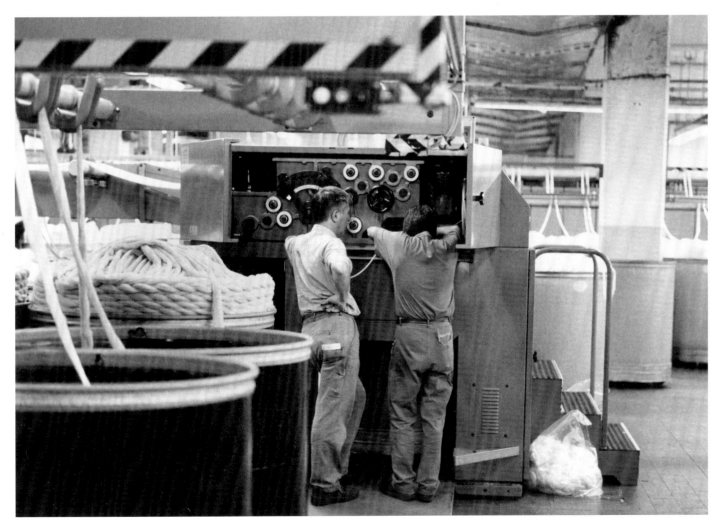

Right page:
Model wearing a suit from the Cerruti 1881 collection, September 1960

Philosophical by nature, Cerruti would seek truth through a sartorial rather than a literary lens. From the start, he had a clear perspective that he put into producing fabrics and, in turn, garments, in the sharp lapel of every suit and the careful crafting of each ensemble created.

More so, Cerruti quickly developed a vision for Lanificio Fratelli Cerruti that would push it beyond its limits. Despite his family's long-standing place in the wool business, they had never produced actual clothes. Cerruti soon realized that they could design and manufacture more than just fabric for others, they could design and manufacture garments themselves.

The budding designer at first collaborated with tailors to create his vision. In what was literally a dramatic turn, he commissioned four short plays from famous writers and designed the costumes himself. The plays were performed across Italy, in Rome, Milan, Turin, and southern Naples and continued to put Cerruti on the map.

Along with his design acumen and knowledge of textiles, Cerruti was also an expert in production. He wanted to produce his style of menswear and womenswear on a mass scale. Silvio Cerruti had already started to innovate the fabrics they produced by altering some of them to be of a lighter weight. The younger Cerruti took it a step further by improving and changing the mill machinery so it could adapt to the new fabrications and new styles.

With the textile business of fine woolens for suiting at his back, Cerruti was given fairly free reign to develop his vision. Textiles were his passion and he took great care to hone the fabric. He had a heritage to rely on with a strong foundation. Self-taught in many ways, Cerruti was intensely curious about the world and widely read–not to mention a natural workaholic. It was this drive and intensity that would carry him, and the company, forward.

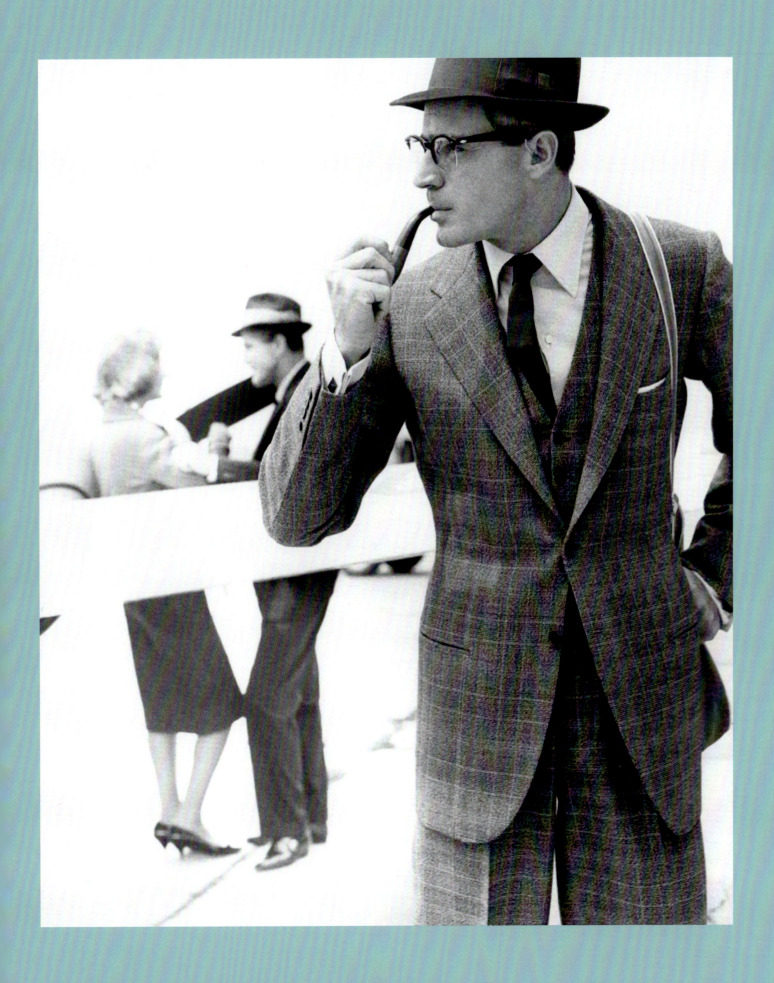

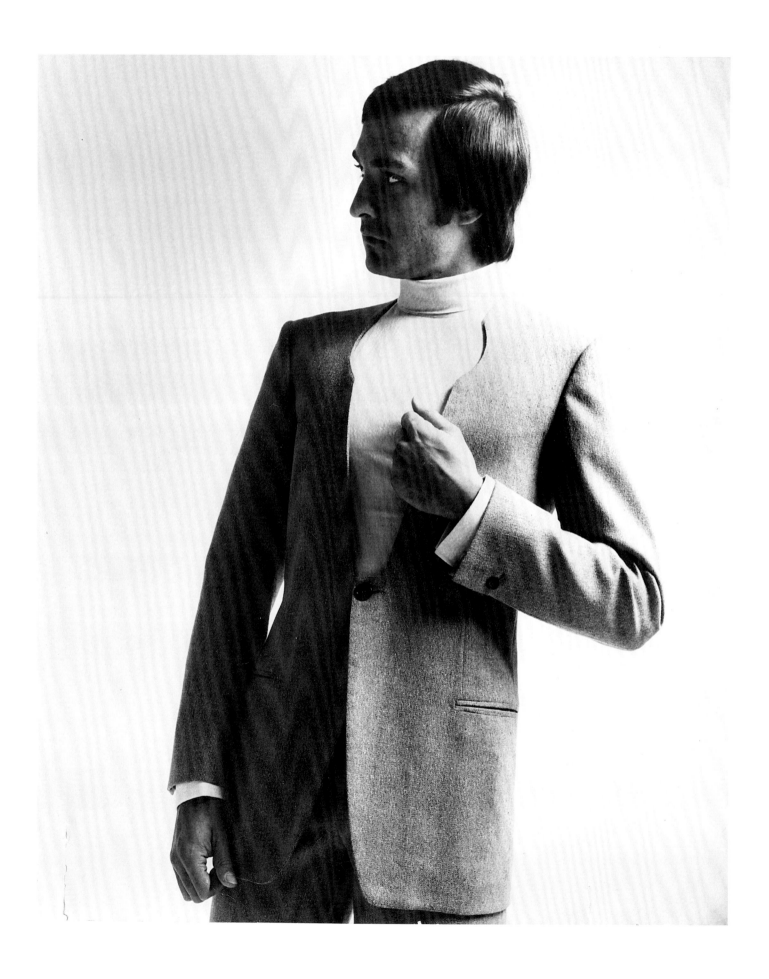

Creativity

Nino Cerruti busted open the seams of what men wore. When he came of age in the 1950s, clothing was taking new directions. The space race was in full tilt, the world's major superpowers were in a Cold War and all-things convenience created a society that was loosening up. Beat poets were waxing nonsensical on the road to the next great adventure while at the same time defiantly capturing a counterculture that would shake things up in the next decade. A new generation was looking ahead to the latter part of the Twentieth Century and laying the groundwork for a vibrant future. Times were changing, and clothing was changing with it. And a young Italian designer was at the forefront of it all.

Cerruti launched his first men's ready-to-wear collection in 1957 in Milan. It was called Hitman and was deemed a revolution by the fashion press worldwide for its atypical shapes and relaxed fits. He designed and launched the deconstructed jacket and by doing so, gave rise to casual chic. Italy, especially, had a long-standing tradition of tailor-made menswear, but ready-to-wear was fast gaining ground. Given the bespoke tailoring of the era, Cerruti's clothing was looked upon as a huge departure from all that had come before, capturing the spirit of the times and the energy in the air.

The sexual revolution of the 1960s was soon upending what was allowable to wear and what was not, and designers were jumping on the bandwagon. Clothing took on new curves and accentuations never seen before. Menswear followed the trends, with an unabashed change-it-up attitude. Men's suits had traditionally been quite literally buttoned-up. The stiff, classic look of an ensemble that fit the body was still something men desired–no one wanted to look disheveled–but Cerruti pushed things forward with slightly more avant-garde patterns, wider lapels, and longer cuts. Pants were fuller. Coats had movement. Jackets spoke to you. It was the details that inched menswear into modern times.

Left page:
A look for men from the
Spring/Summer 1969
Hitman Collection

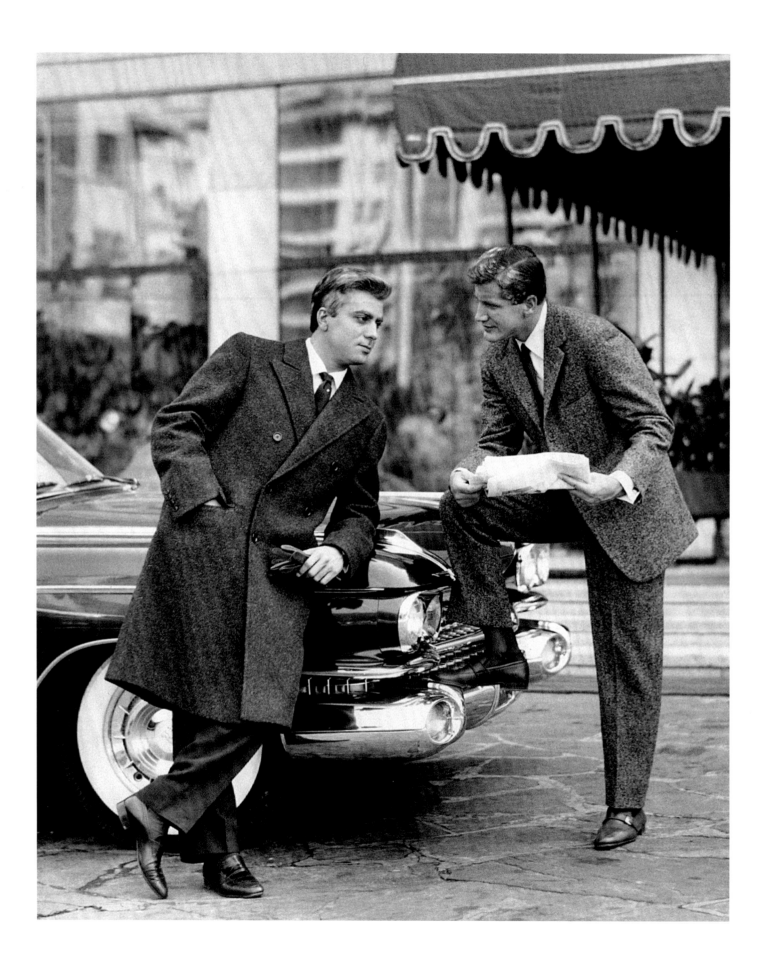

*I want men freer
in their elegance,
more elegant
in their freedom.*

Nino Cerruti

Previous page: Model at left wearing an alpaca and mohair overcoat, Cerruti 1881 Fall 1960 Collection

At left and opposite page: Three looks for men from the original Flying Cross Fall 1969 Collection

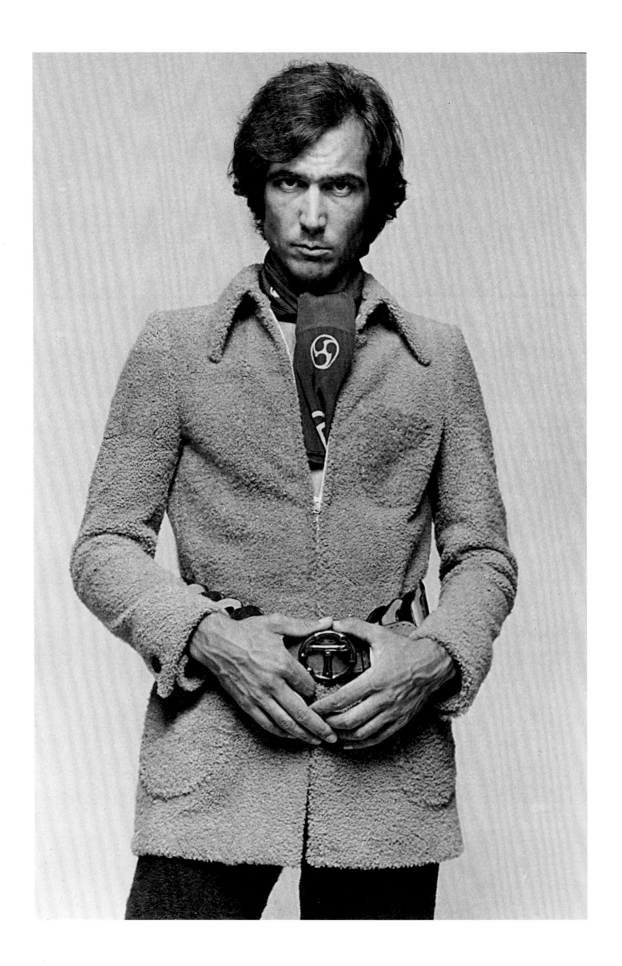

"What he managed to do was something very special," says Jean-Paul Knott, Creative Director of Cerruti 1881 from 2007 to 2011 who worked alongside Msr. Cerruti and benefited from his sage advice. "He created the first men's ready-to-wear collections. There was no men's ready-to-wear before Nino. Very few people know that." In 1962 together with designer Osvaldo Testa, Cerruti founded the brand Flying Cross, one of the first collections deemed "designer" and an adjunct to the Hitman line. It was even more of a sensation, with the deconstructed jacket as the centerpiece and materials that were anything but conventional. Fabrics took on offbeat compositions, with patterns that were as groovy as the times.

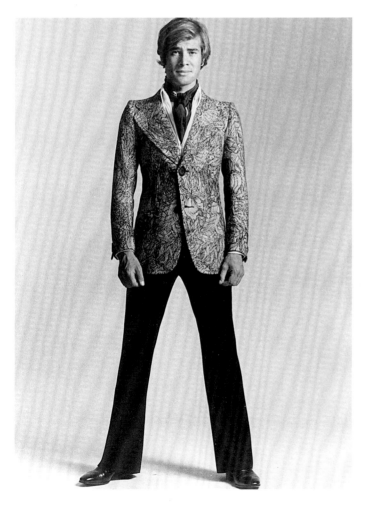
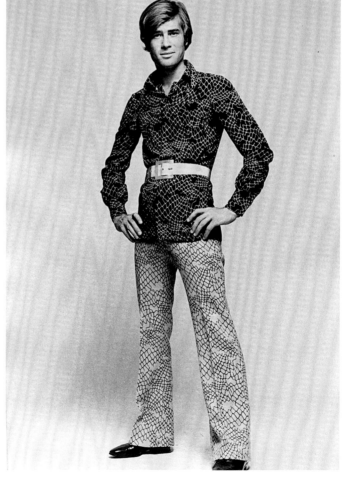

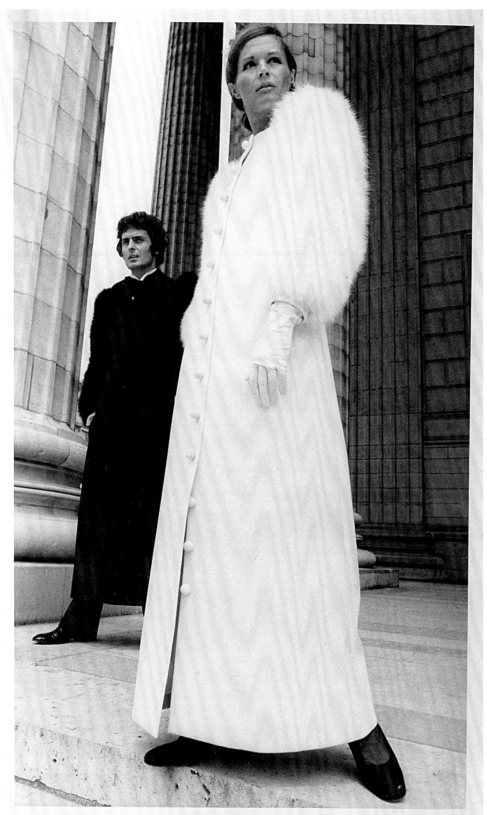

Manteau du soir long, blanc, ras du cou, près du corps, boutonnage jusqu'en bas, manches de renard blanc.

Long narrow white evening drap overcoat with white fox sleeves.

I'm not altogether fond of words like fashion, elegance, or style. They are old and outmoded. I would replace all of them with the word 'harmony,' meaning a garment's fidelity to its wearer.

— Nino Cerruti

Along with his creative talent, Cerruti quickly revealed his acumen for business, as well. In 1964, he hired a young menswear designer to work on the Hitman collection by the name of Giorgio Armani. Four years his younger, Cerruti recognized his talent right away. Armani, who would soon become the designer's protégé, worked at the house in Paris before leaving to establish his own company in 1974. The younger Italian would carry with him some of the influences Cerruti put forth, including an ease of dressing, boldness, and, always, sophistication first.

Nino Cerruti wanted clothes that made way for a new age that was emerging. Indeed, the designer himself embodied casual chic: as a very tall and slim man, he served as a ready-made model for his own designs. The facets he held dear though: the finest fabrics and an ease of dressing. The twin notions would carry Cerruti's work into the fashion annals.

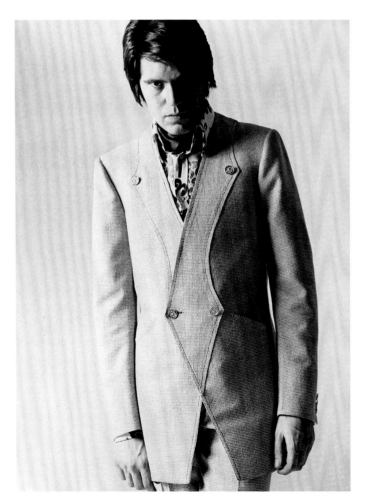
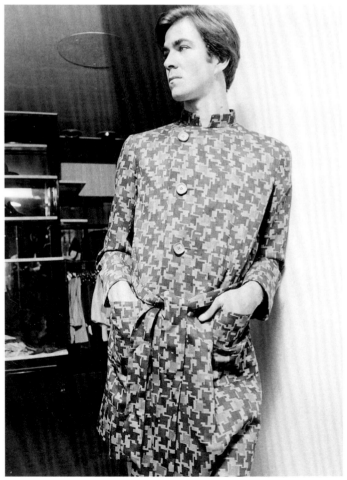

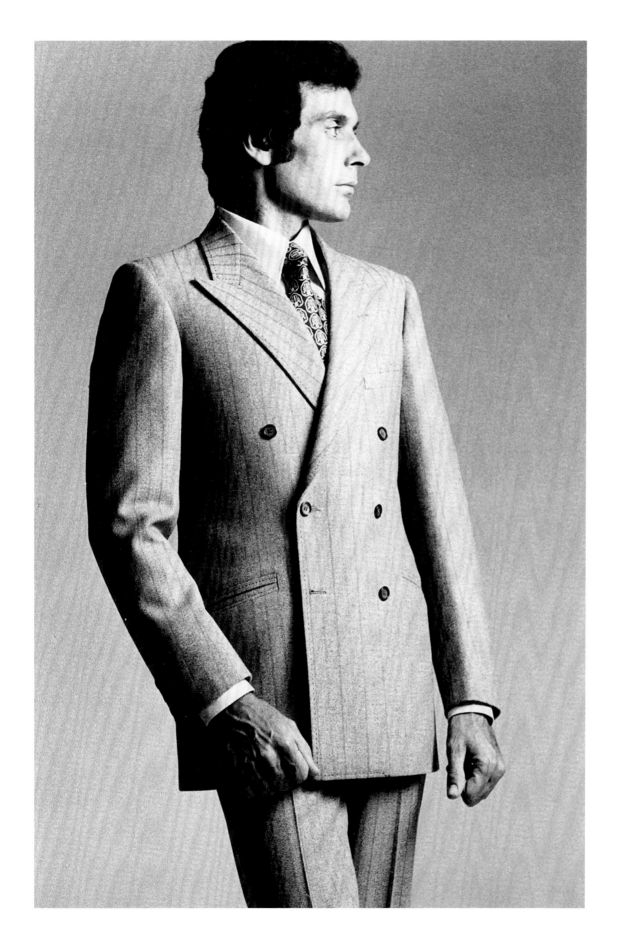

Previous page:
Chantal, Nino's wife and business partner, wearing a Cerruti creation, early 1970s

Opposite page:
Two completely new and different looks for men, Spring/Summer 1970 Collection

At left:
An impeccable Cerruti suit, Fall 1969 Hitman Collection

Next pages:
Menswear looks from the Fall 1969 Hitman Collection

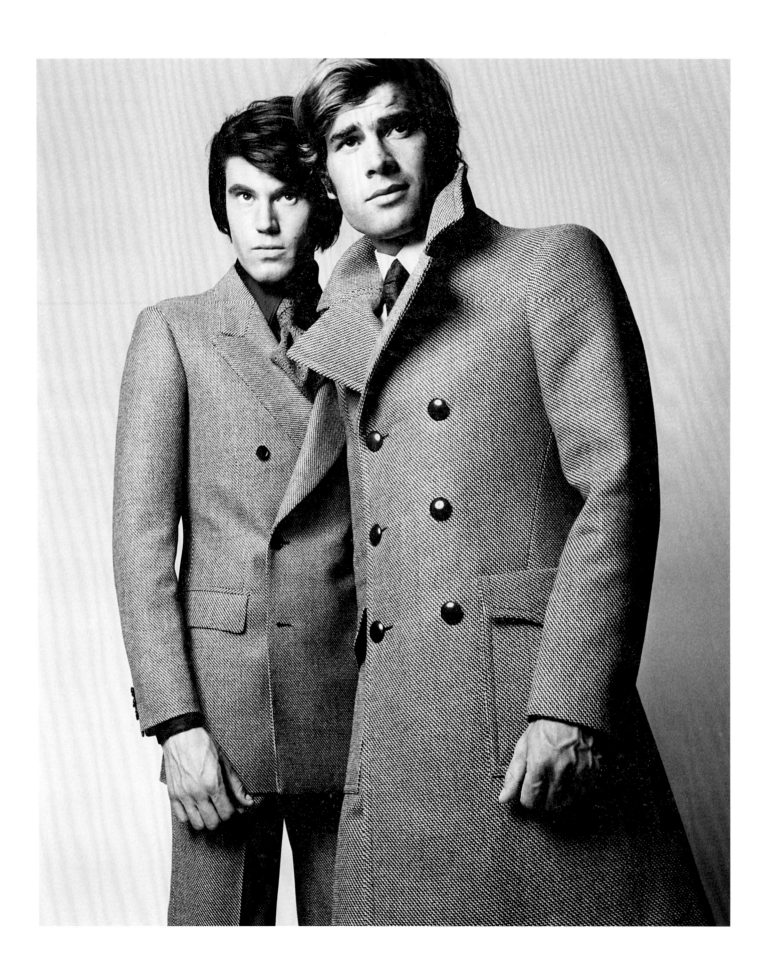

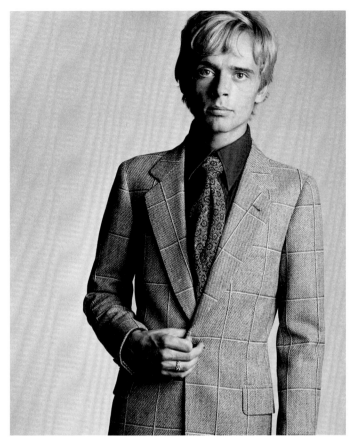
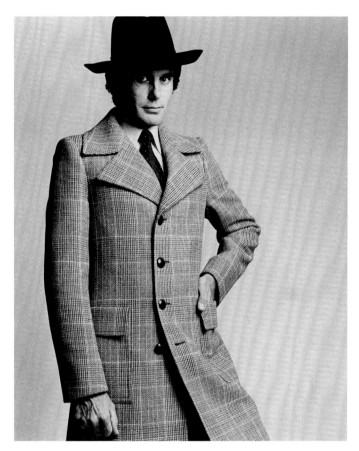
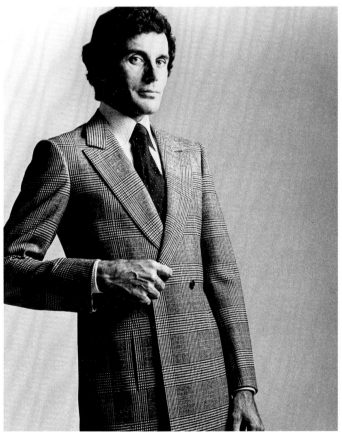
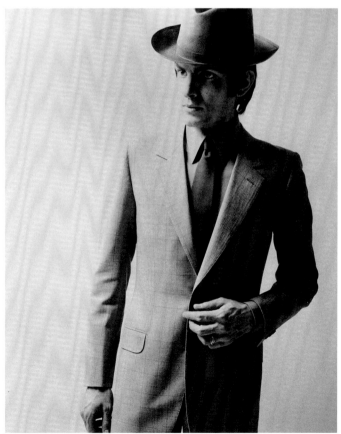

My father called himself a couturier. The term 'fashion designer' wasn't in use back then. Every house presented their own collections. It was very different, and had a certain level of class to it.

— Julian Carruti

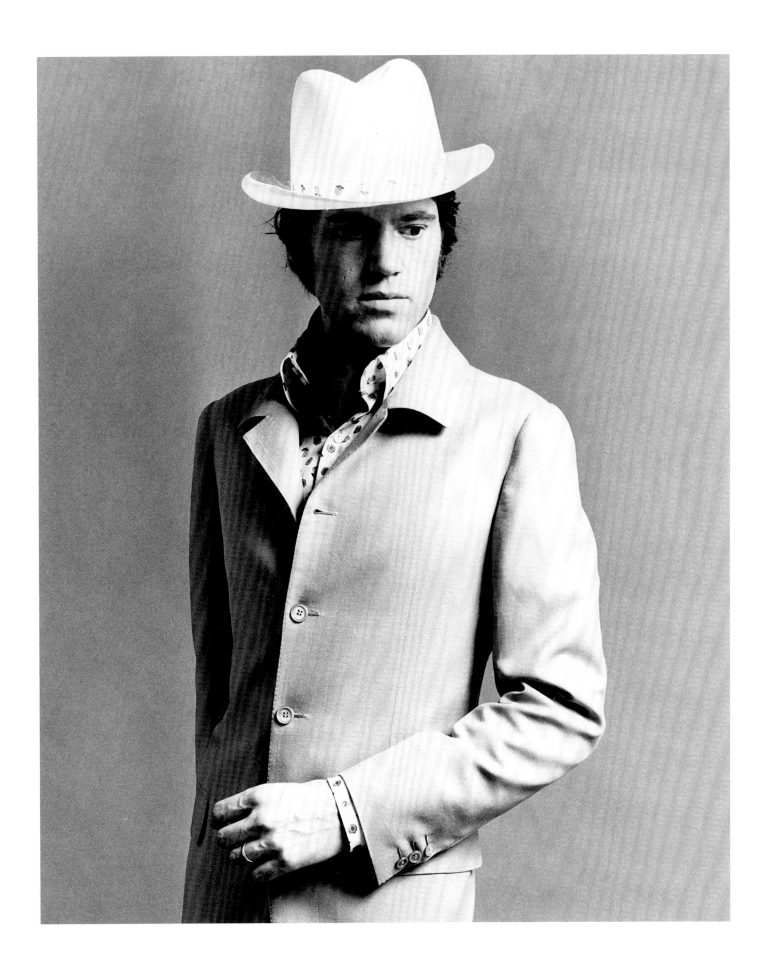

Family Business

The personal life of this young businessman was taking shape as well. Cerruti met his first wife, Diana Gates, while skiing with friends in the French Alps. In their late Twenties, they were engaged very shortly thereafter. A church wedding in Biella followed, where the couple settled and had one daughter, Silvia. The marriage was dissolved, however, nearly nine years later.

In 1967, Cerruti met Chantal Dumont, a young model, on a plane while both were flying to New York. She was on her way to walk the runway for Valentino's latest collection. Dumont was Parisian, young, and a stunning beauty. Highly smitten, Cerruti pursued her and the two soon became a fashionable couple.

Chantal–as she was professionally known–became a model too for the House of Cerruti and an incremental part of it all, eventually running operations for the company, dealing with the press, and handling VIPs as well as the stars of both screen and sports.

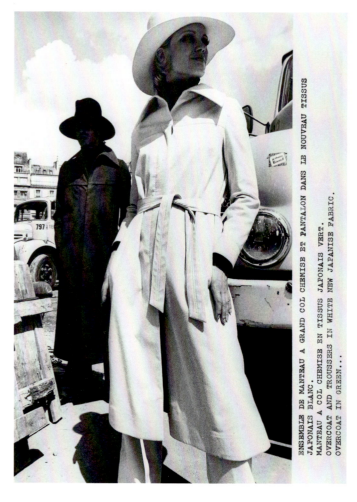

ENSEMBLE DE MANTEAU A GRAND COL CHEMISE ET PANTALON DANS LE NOUVEAU TISSUS JAPONAIS BLANC. MANTEAU A COL CHEMISE EN TISSUS JAPONAIS VERT. OVERCOAT AND TROUSSERS IN WHITE NEW JAPANISE FABRIC. OVERCOAT IN GREEN...

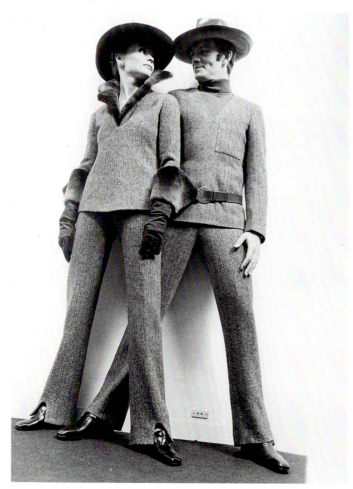

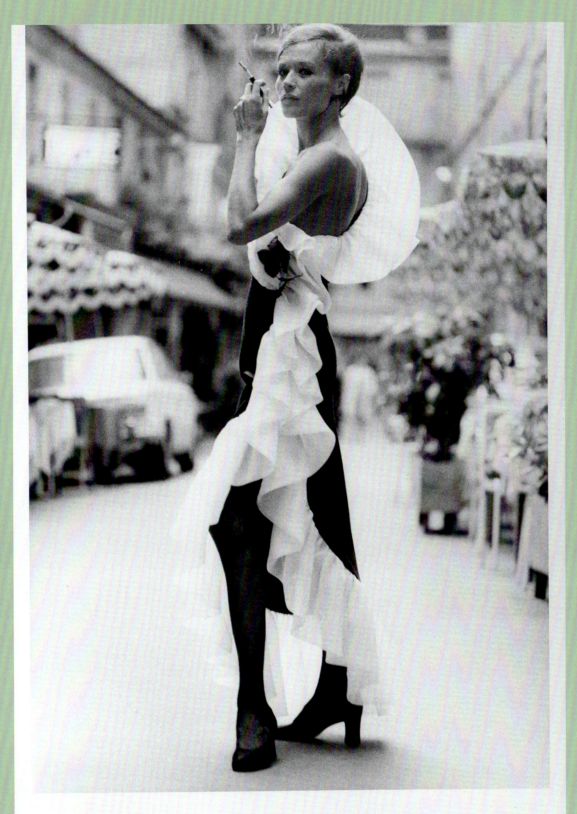

Robe en satin noir, assymétrique, bordée d'un volant en organza blanc.
Black satin evening dress with white organza ruffles.

At left:
Chantal models a black satin evening dress, 1970.
Opposite page: Chantal models an overcoat and trouser ensemble; unisex clothing, all 1970s

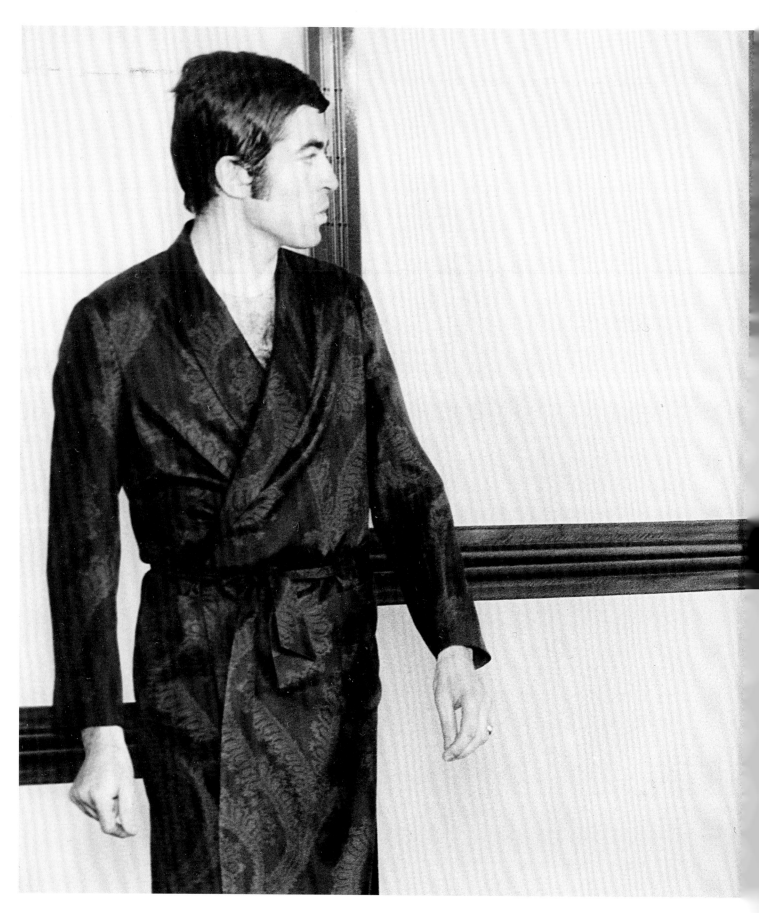

**Stylish bathrobes modelled
in Cerruti atelier, Paris, 1970s**

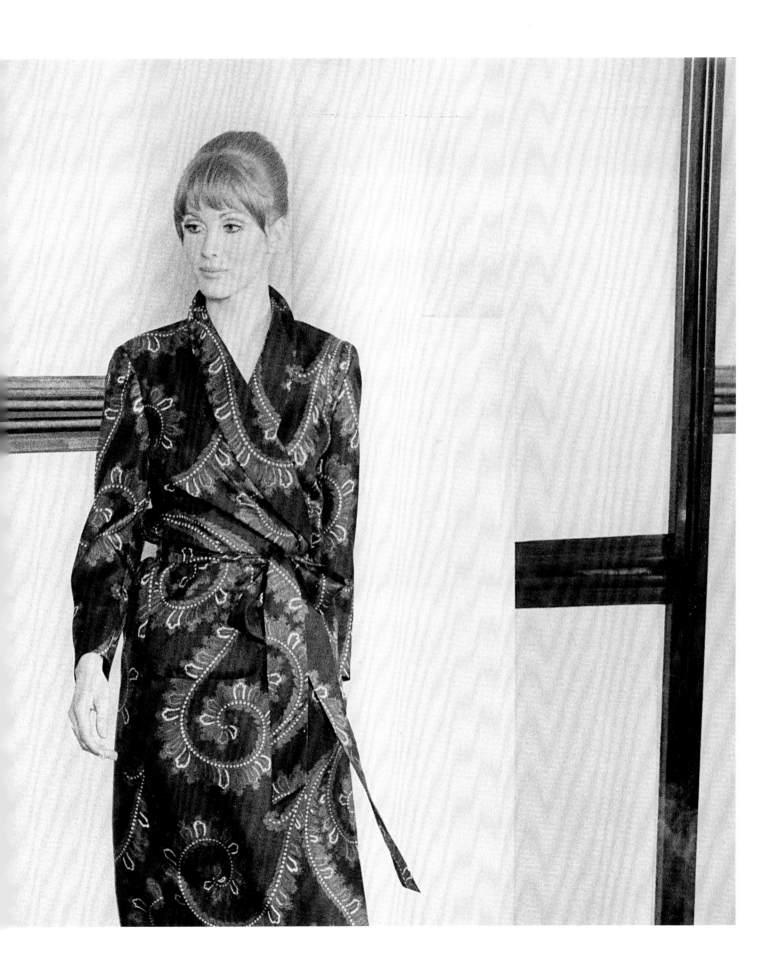

This page:
Models outfitted in corduroy ensembles danced to music in the Cerruti atelier for the Fall 1969 Collection.

Opposite page:
Two looks for the Cerruti Spring/Summer 1969 Collection

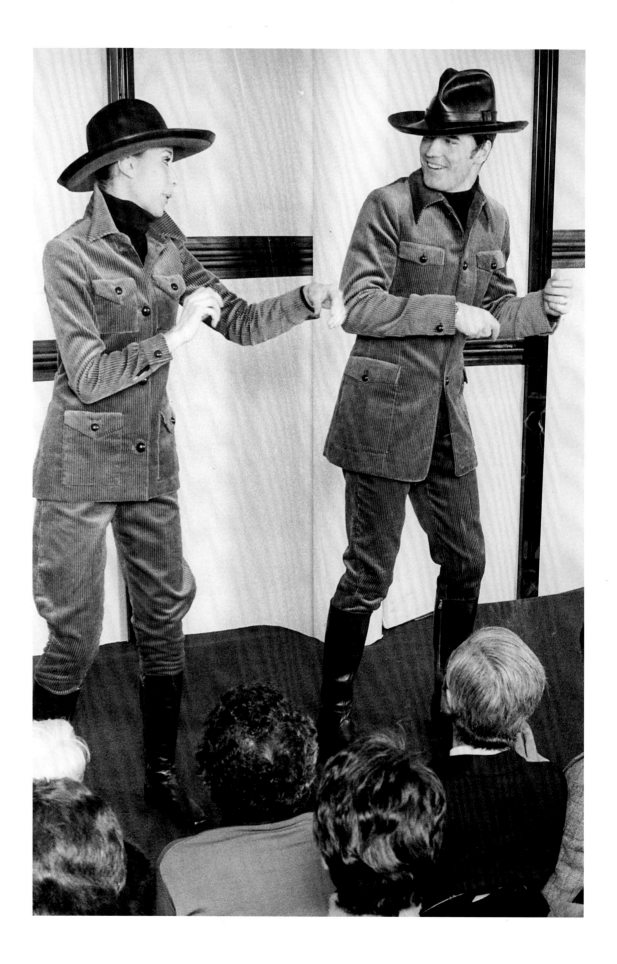

Cerruti's meeting with Chantal coincided with the opening of his first boutique, Cerruti 1881, on the Place de la Madeleine in Paris, along with the headquarters in the fall of 1967. Instinctively, Cerruti knew that the French capital, more so than Milan, was the epicenter of global fashion and the place he needed to situate his house to make it grow and compete. Prêt-à-porter would thrive there as would haute couture. When he first arrived on the Right Bank, there were very few competitors; only about ten true fashion houses existed and everyone knew and respected each other.

Cerruti, however, made his mark with his signature fine fabrics and intelligent Italian tailoring. He kept textile and garment production in Italy and undertook the vibrancy and verve of Paris, which offered the burgeoning designer an international platform.

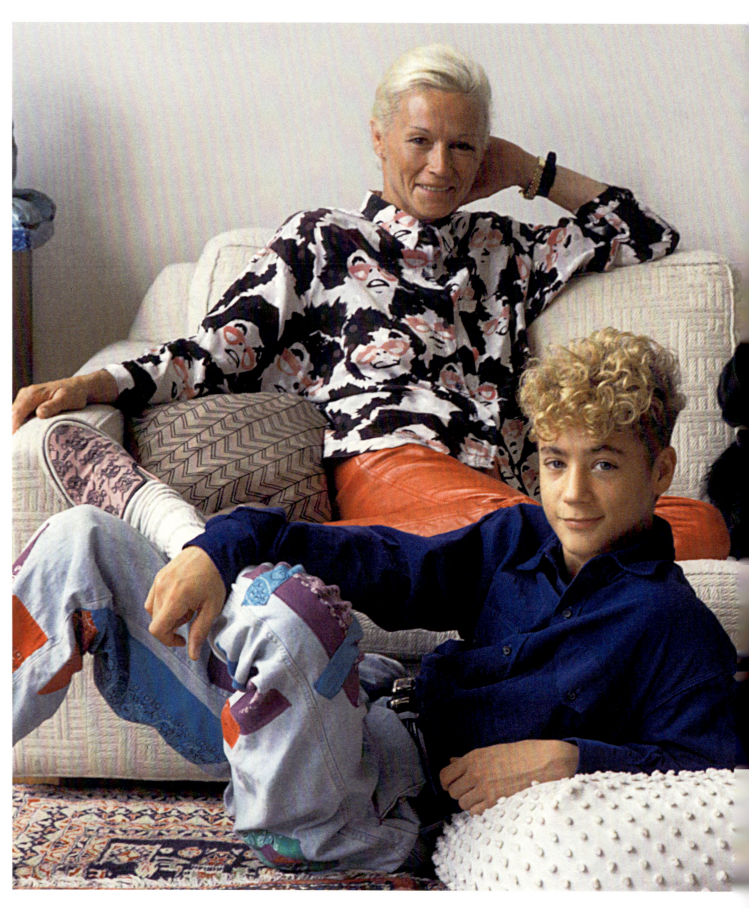

In 1973, Chantal and Nino gave birth to a son, Julian. Outside of Cerruti's fashionable business swirl, the family led a regular life in Paris, social enough but quiet at home. Vacations were family affairs for the most part, with St. Tropez a frequent destination, France's playground and arguably one of the coolest spots during its heyday in the 1970s. The photo above shows Chantal, Julian and Nino Cerruti in the summer of 1988.

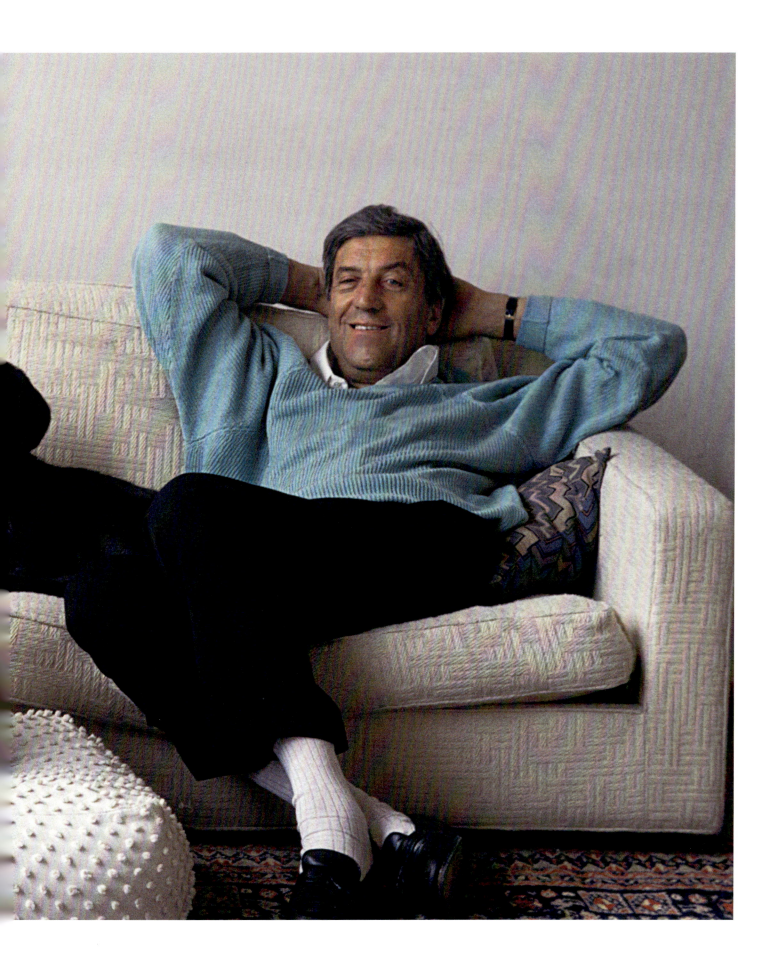

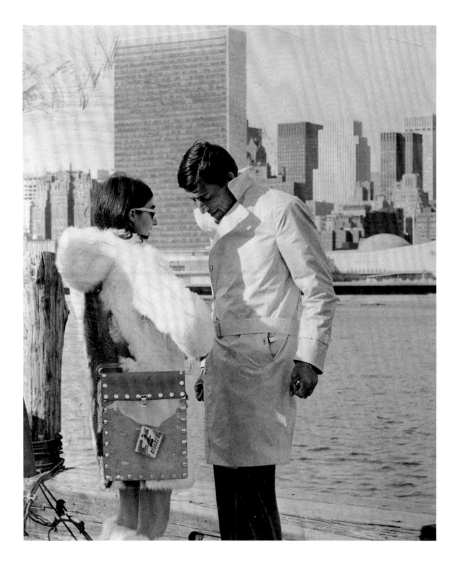

Nino and Chantal visited New York frequently.

**At left:
Nino Cerruti on the East River in New York**

**Opposite and following page:
The couple visit Harlem, mid-1970s**

Nino Cerruti, was never one to sit on the beach. Fashion was competitive and Cerruti was a workaholic; he had few other interests besides perfecting the garments under his care. "He was very vivacious, always on the go. He loved what he did," says his daughter Silvia, who would see him weekly when he traveled to Biella, where she lived with her mother. He found stimulation in both places, loving Paris for its creativity and beauty, and cherishing Biella for its solidity and stillness.

It was a jet set life with trips to Italy to observe work at the mill, and in Paris for the company, and anywhere else in between that his growing business would take him. He and Chantal would often venture to New York, among many locales, to promote the business.

Life back home in Paris gave Cerruti a chance to promote his business in every way. He associated with the best in society, with loyal clients quickly making repeat visits to the Place de la Madeleine, among them Faye Dunaway, Orson Welles, and Rudolf Nureyev. Cerruti's sphere included famous French TV journalists like Charles Villeneuve, fashion circle executives like Jacques Mouclier, the former President of the French Federation of Couture, and heads of industry.

Christmas was had each year at Roman Polanski's, where the famed director would make his staple dish, zamponi–stuffed pig's legs–for the dinner. Marlon Brando was a friend as well as a client, ordering custom-made capes in his later years to keep the drama alive.

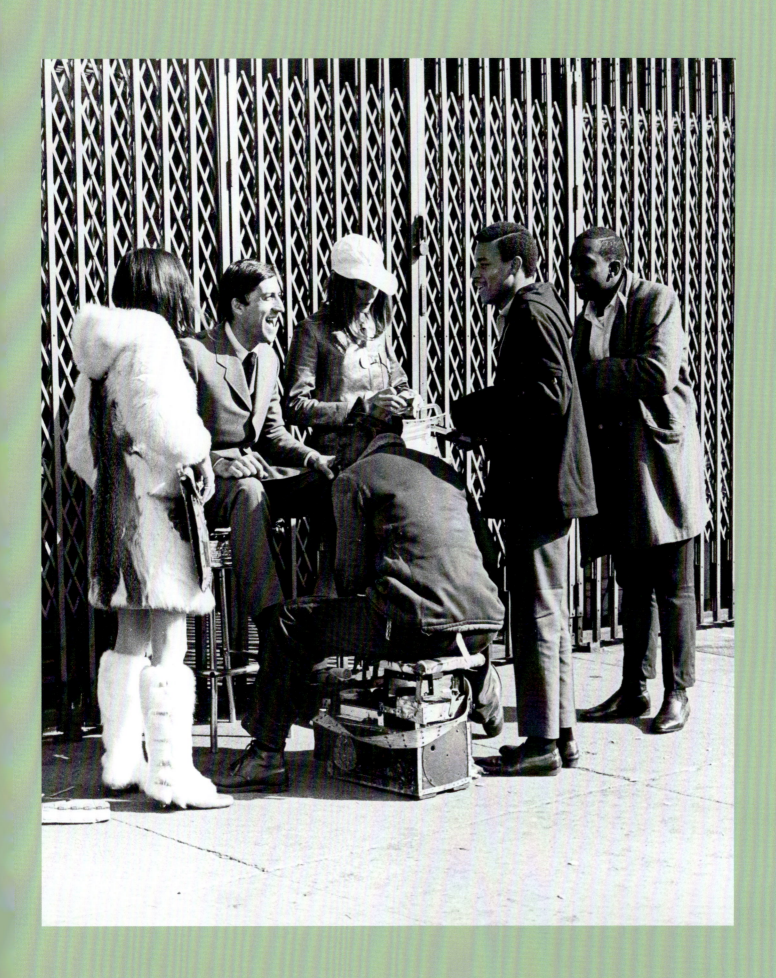

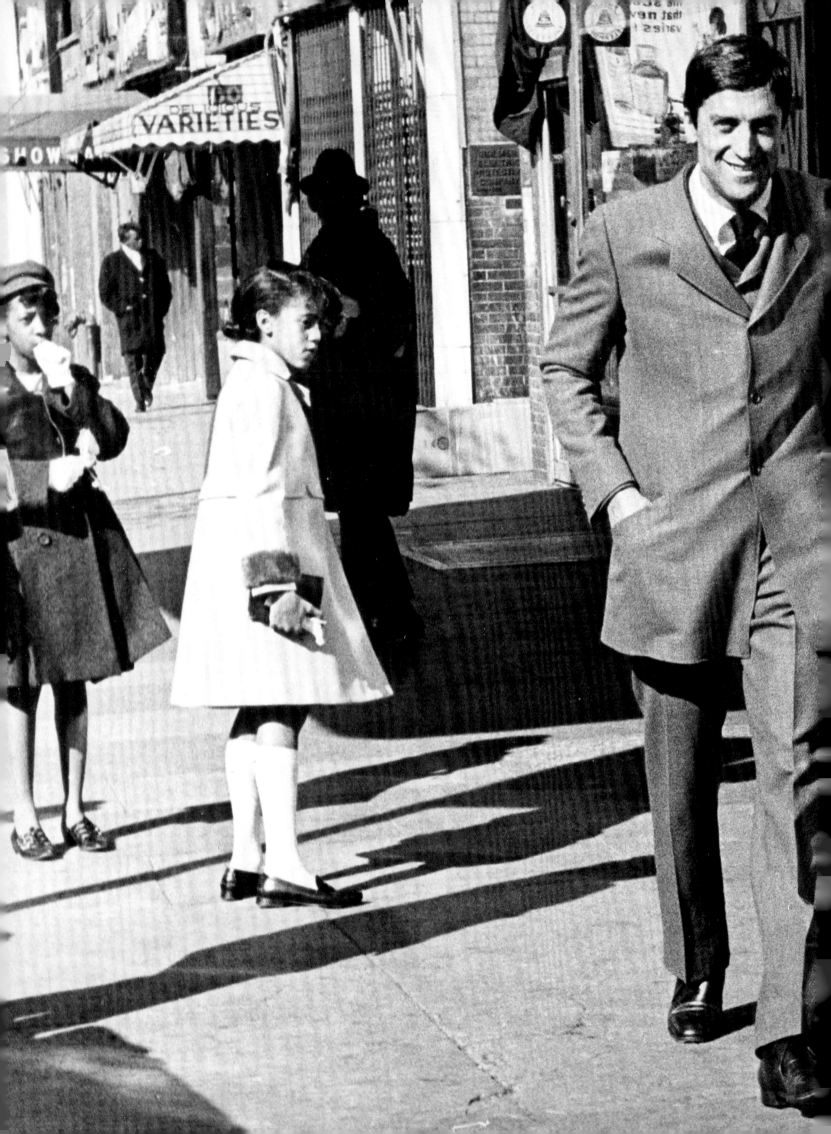

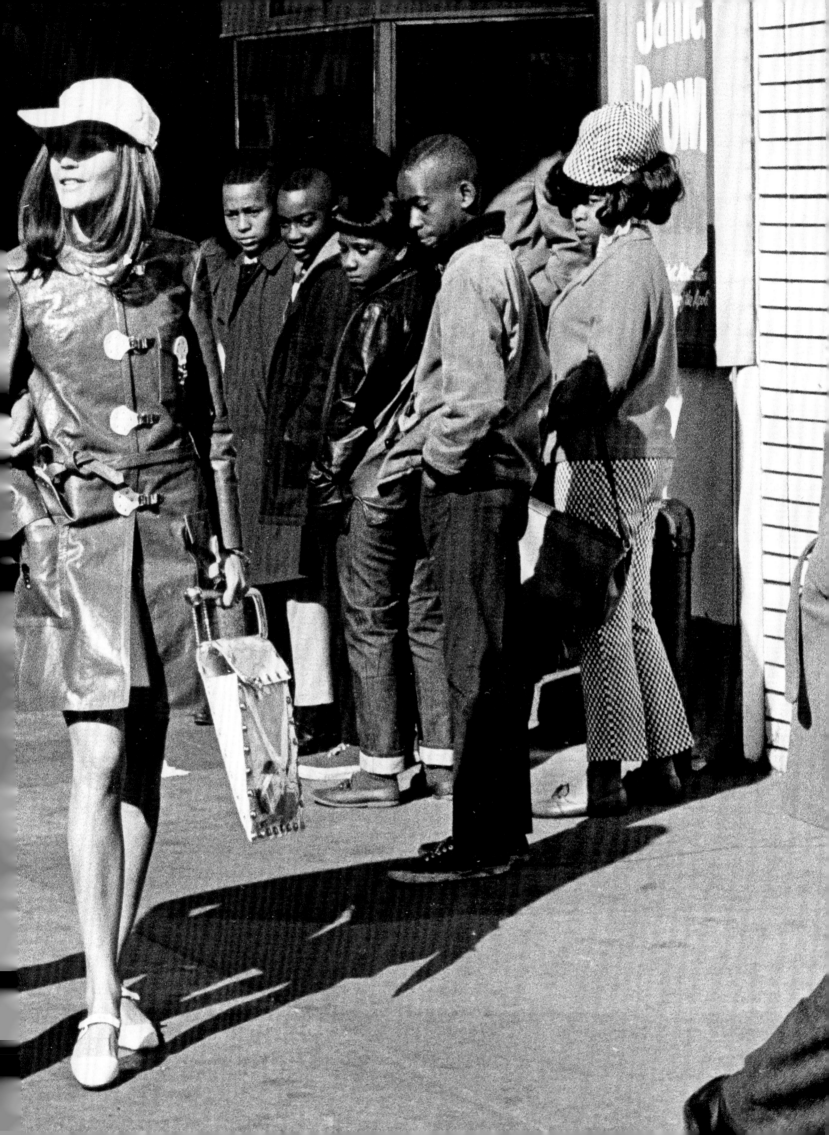

Suzy Menkes, the international fashion critic, famously employs "BC" not for its biblical reference but as one that refers to menswear. "Before Cerruti" was an era when suits were staid and without the movement that his fluid designs introduced. As he stepped onto the world stage, Cerruti brought with him a sense of European elegance and daring.

Cerruti's business made a rapid ascent. He continued to garner the favor of the fashion press, especially that of Diana Vreeland, Editor in Chief of American *Vogue*. "She was fond of him but she also truly supported what he was doing, so it took off fast," says Julian Cerruti. The looks of the day–even those more formal–veered toward the relaxed refinement at work in the culture. Building a suit was architecture for Cerruti. He understood the construction of a piece of clothing on an intimate level and how the malleability of the fiber played itself out once it hit the body.

Cerruti utilized the long-standing techniques used by the craftsmen at Lanificio Fratelli Cerruti while employing new, more elevated factory production to create his ready-to-wear. He also experimented, adding synthetic fibers and introducing jersey fabrics and knitwear to his lines, to adjust the fit and wearability while retaining the "Made in Italy" stamp.

**At right:
Suiting from the
Spring/Summer
1969 Hitman
Collection**

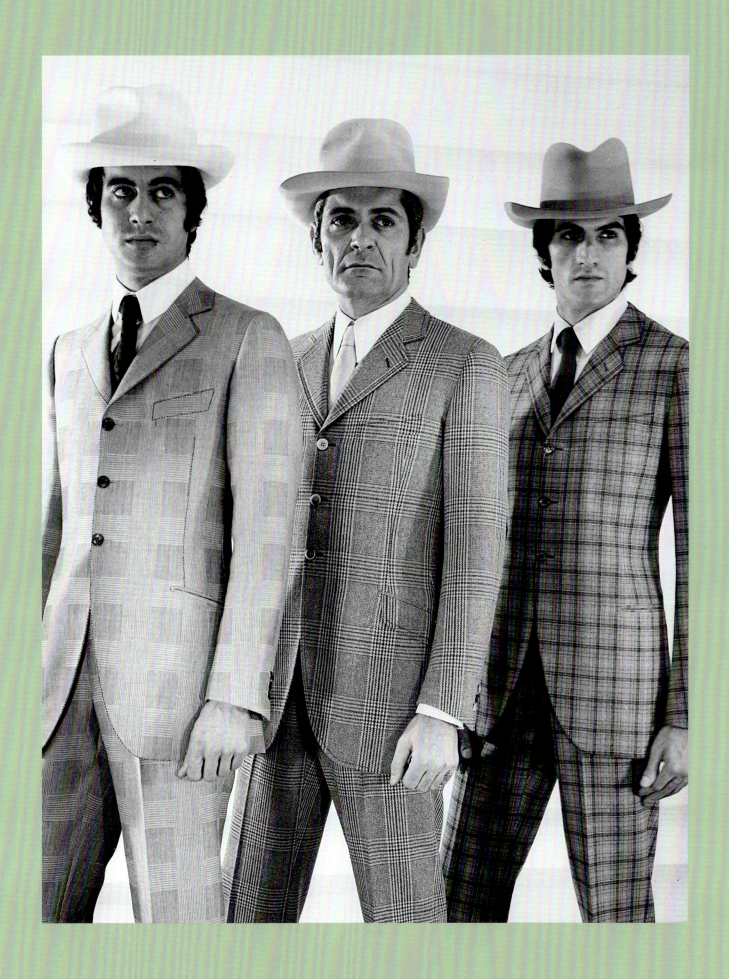

In May 1968, all this came to a personally presented collection which moved away from traditional canons. Garments were less structured. I introduced one-off creations, like the cardigan jacket, experimenting with looser fabrics, innovative patterns and colors which took their leave from the conventional designer's palette.

Nino Cerruti

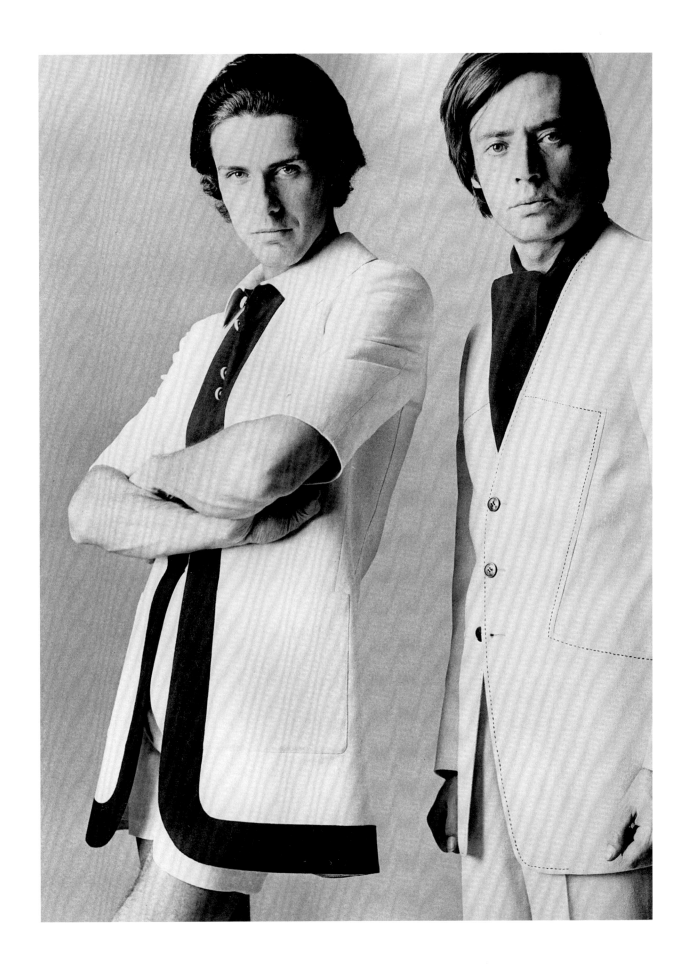

A Woman's Touch

Cerruti didn't merely create menswear: He added his first women's collection in 1968. The Women's Liberation Movement had taken hold and skirts had reached new heights, shorts were considered acceptable to wear off the beach, and women dared with style heretofore unseen. Pants were now ubiquitous and Cerruti knew how to dress the woman of the day, who was increasingly stepping into her own. Prim was out, as far as he was concerned, and bold was in.

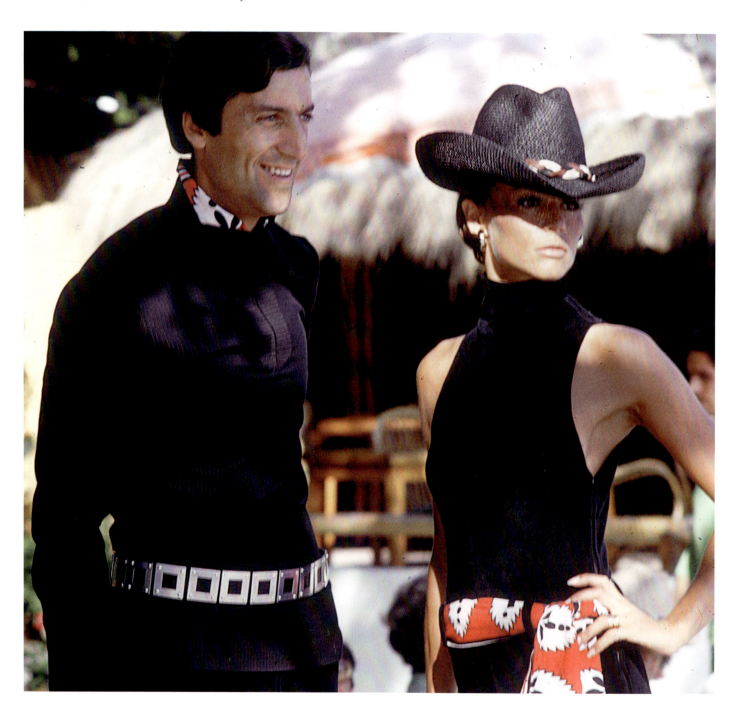

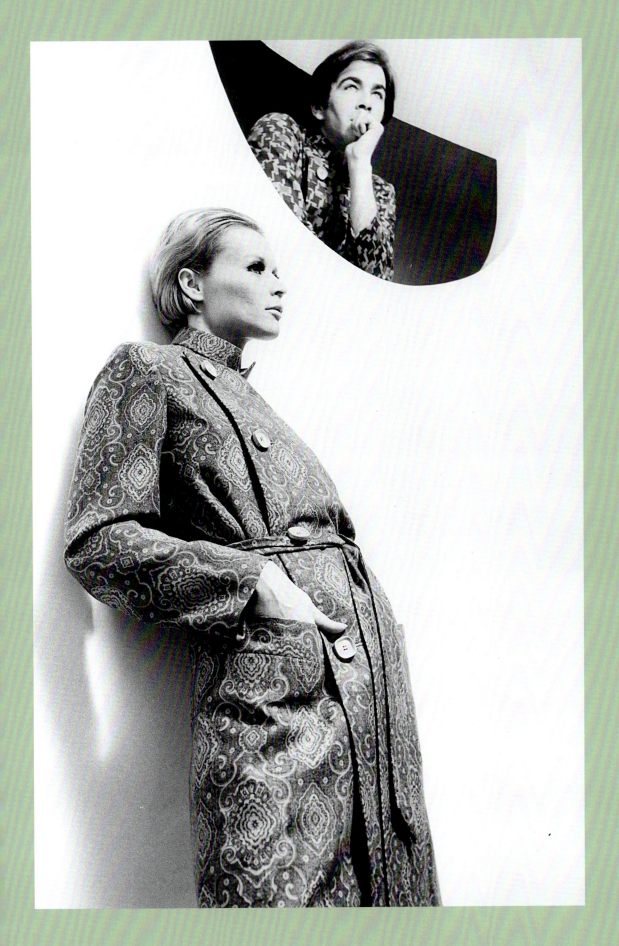

Previous page: Revolutionary looks for men, including the cardigan jacket

Opposite page: Chantal and Nino in Capri, September 1970

At left: Chantal models a look from the Spring/Summer 1969 Collection.

A male model sports new corduroy suiting.

Opposite page: Sketches of new looks, Spring/Summer 1972 Collection

As the Seventies gave way to the Eighties, Cerruti saw that mainstream culture had embraced not only innovation but design and mere clothing itself.. Society had progressed and with the rise of the middle class, people traveled and had more disposable income. Style became more experimental with the glimpse into other cultures with travel and the rise of technology. As only Nino could put it, "Fashion was now a part of everybody's lives."

Completing the Picture

As his business succeeded, Cerruti expanded his name and his licenses in every category, most notably fragrance. In 1978, the designer created his iconic fragrance for men, Nino Cerruti Pour Homme.

The desire was to craft a scent that reminded him of playing in the hay of a barn as a child. Raw as this sounds, it worked and was a hit. Pour Homme was soon followed by Cerruti Fair Play and in 1987 the first perfume for women, Cerruti Pour Femme. Three years later Cerruti 1881 debuted to great success, followed by a version for women four years hence. Image, the next fragrance, came onto the market for both men and women.

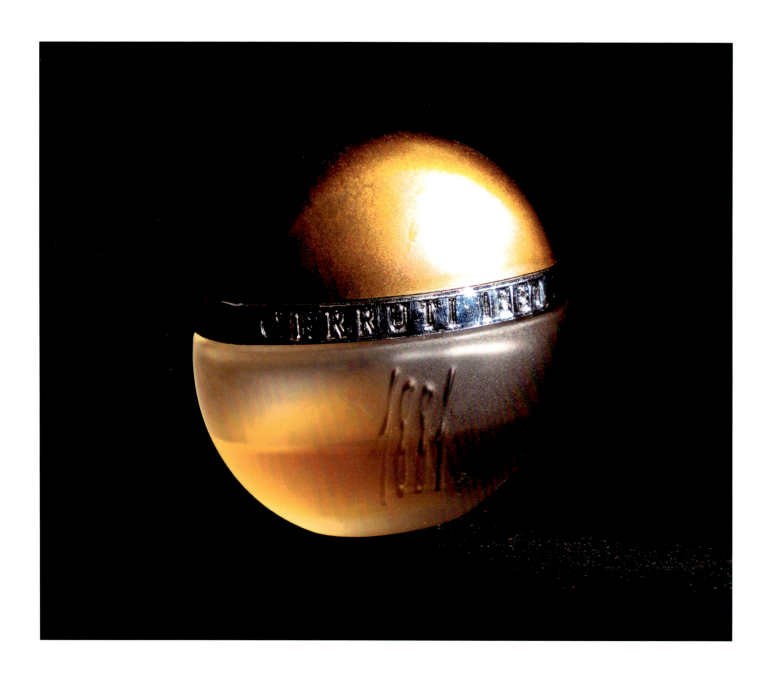

Perfume opens endless horizons. It appeals both to the senses and to the imagination. Like an enchantment, it works on an instinctive level.

— Nino Cerruti

Where there was clothing, there need be accessories. Launched from the start, Cerruti knew the value of a complete outfit, so set out to create accessories in every form, including shoes, belts, bags, scarves, watches, ties, and gloves. Licenses developed as a natural evolution to the clothing. Hats were seen from early on, with the cowboy, the Borsalino, and the Panama all making appearances. Over the years, leather goods, jewelry, eyewear, writing instruments, underwear, socks, nightwear, and loungewear were all added.

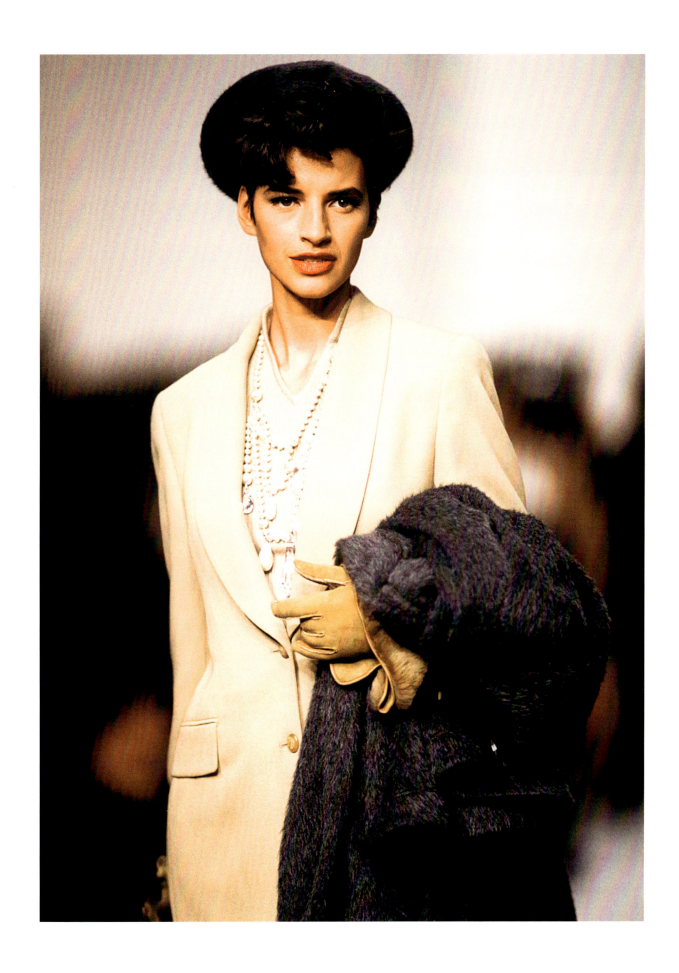

Men's vinyl swimwear, early 1970s

Opposite page: Playful sketches for men's and women's swimwear, Spring/Summer 1972

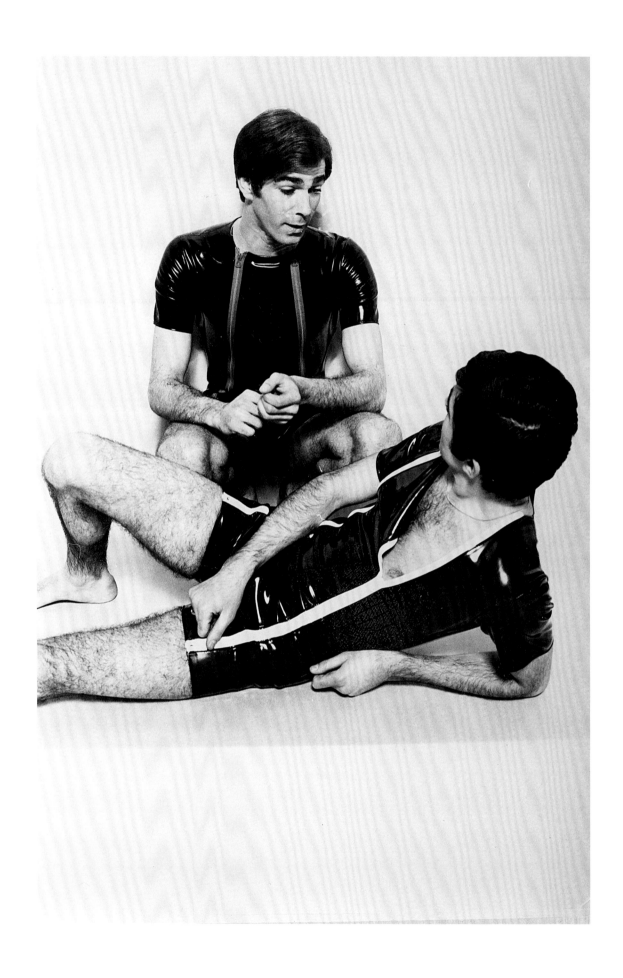

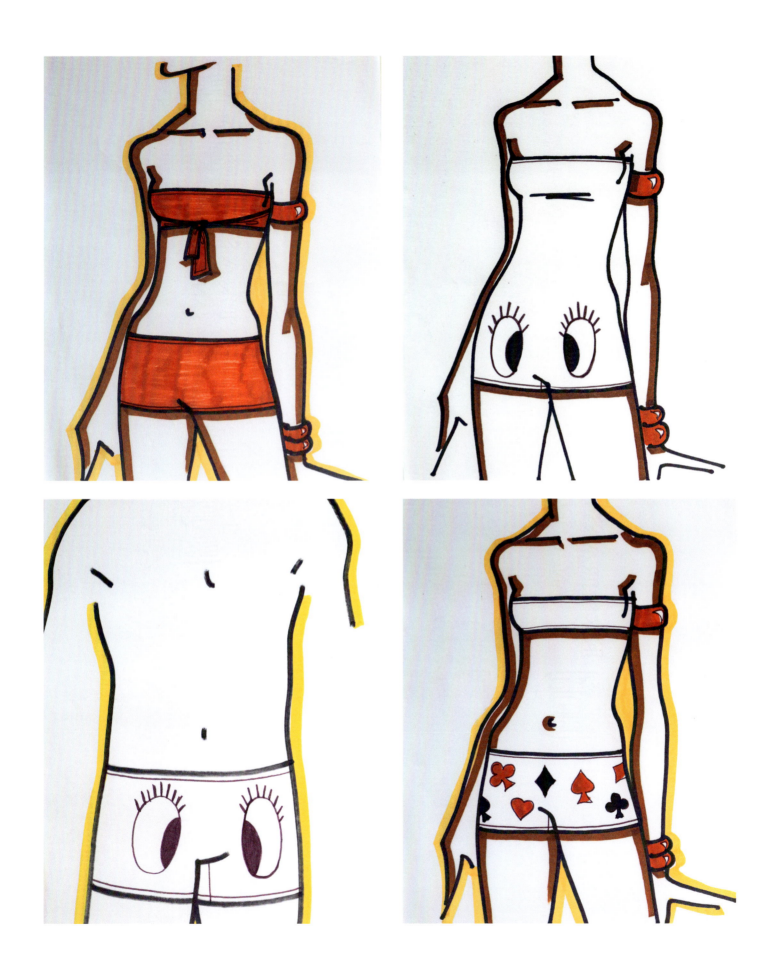

Clothing should accompany the individual's personality and not overwhelm it.

— Nino Cerruti

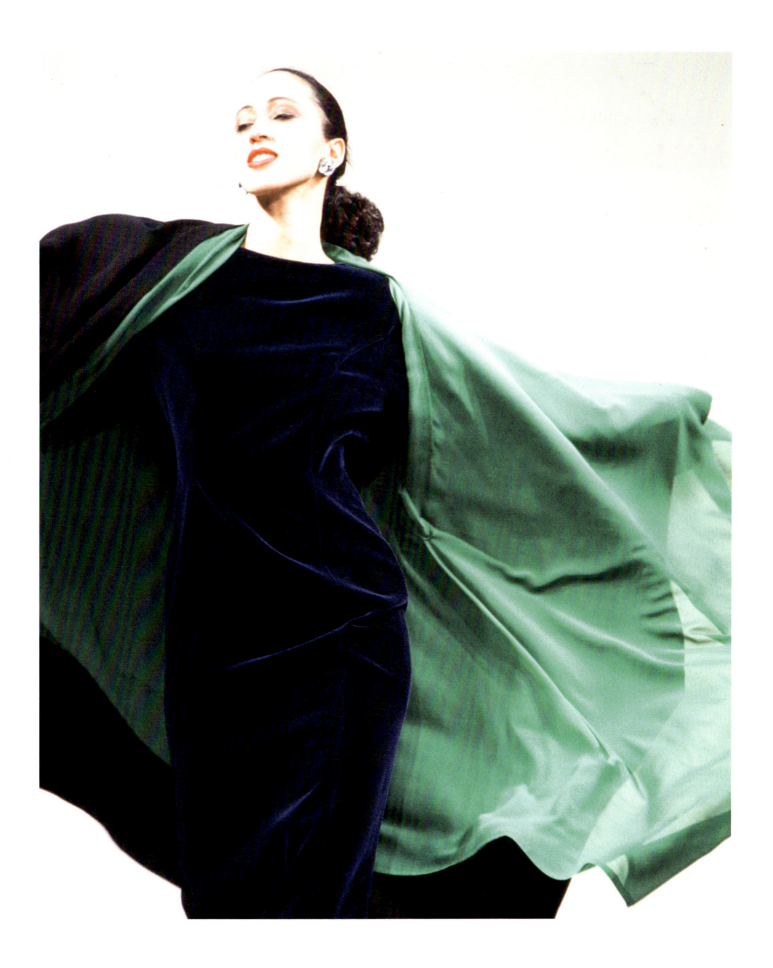

The Age of Excess

The Eighties. The mere utterance of the words conjures up a decade of difference, when fashion took a right turn from all it had known. Yuppies, not hippies, ruled the day and peace and love was replaced by greed and go-go. Corporate raiders flaunted their pinstripes and women marched to work in droves clad in power suits and running shoes.

Aside from fashion's conservative facets, a further level of freedom emerged. Garments got even more voluminous. Shoulders sloped or were cut off altogether. Coats expanded and lapels continued their modulations. Pants adopted peplum waists and skirts descended to new lengths. A color explosion was seen all around, in magenta and chartreuse, as well as all-black formulations. This was the age of punk rock and MTV, a newfound yet different type of sexual revolution where gender bending was all of a sudden out of the closet, and the clothes had come with it. As always, Cerruti stayed on point. His clothes held their own in their completely-of-the-moment iterations

Style continued to make its 180, with fuller pants, stripes galore, and the domination of natural fabrics, like cotton, linen, and silk.

Previous page: Drama takes hold in the Cerruti Fall/Winter 1985 Ready-to-Wear Collection.

At right: A sketch from the Men's Fall 1981 Ready-to-Wear Collection

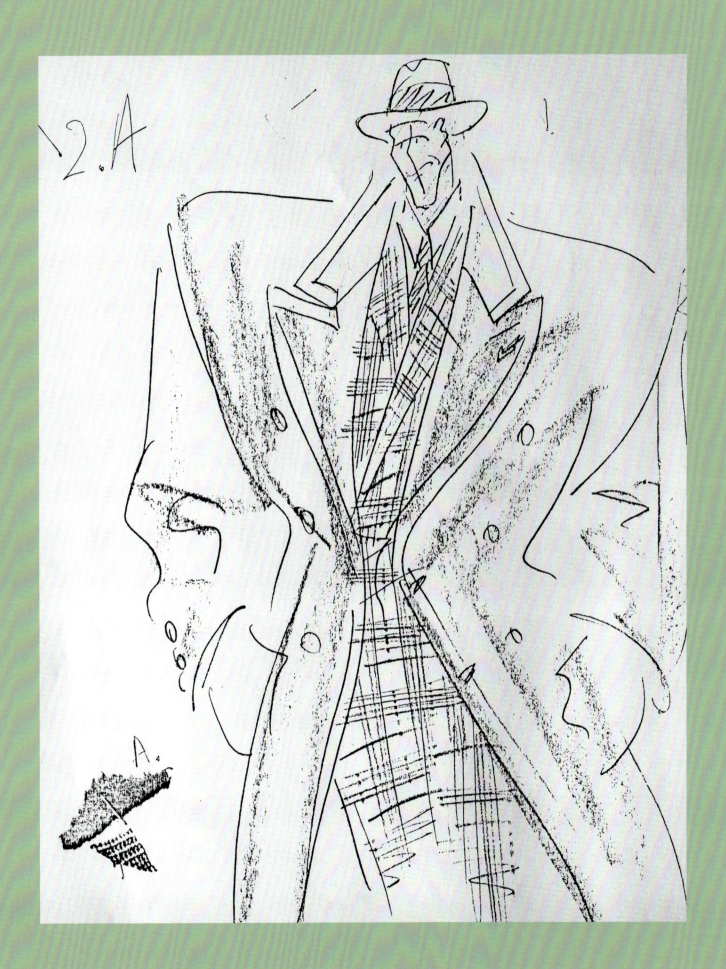

The question he was always taking into consideration: Are the pieces appropriate for right now?

Jason Basmajian, former Creative Director, Cerruti 1881

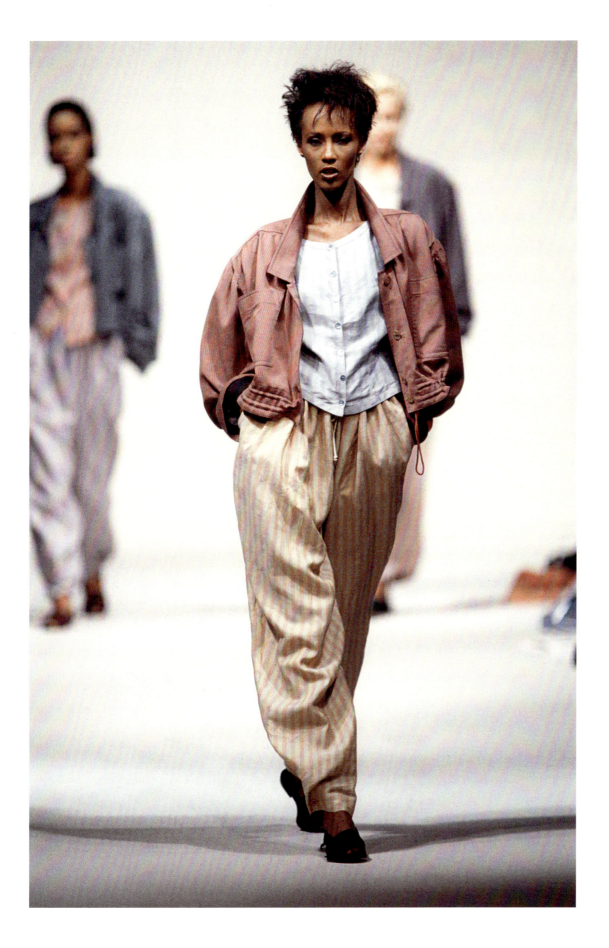

Legendary model Iman walks the runway for Cerruti's Spring/Summer 1985 Ready-to-Wear Collection in Paris.

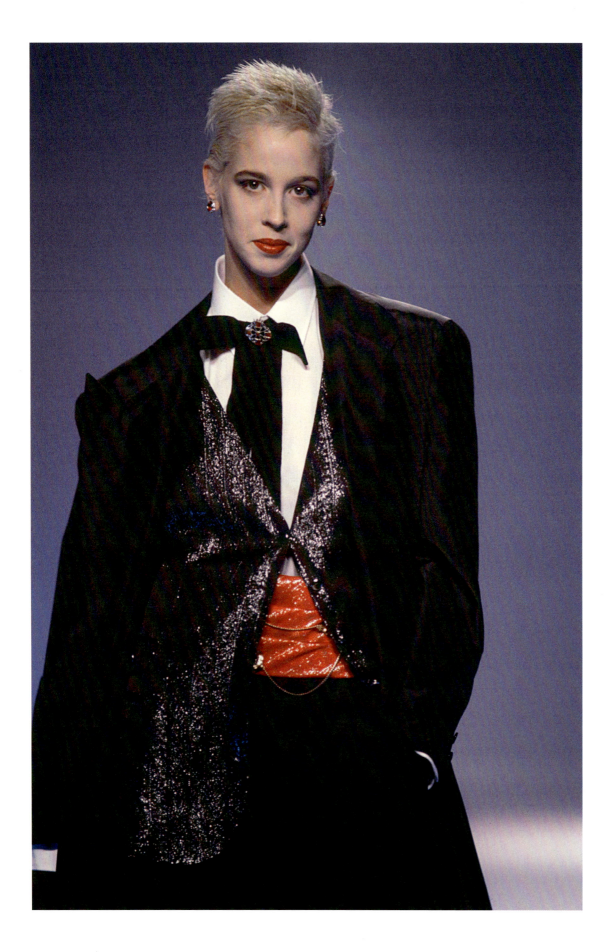

Fall/Winter 1985
Ready-to-Wear
Collection for
women

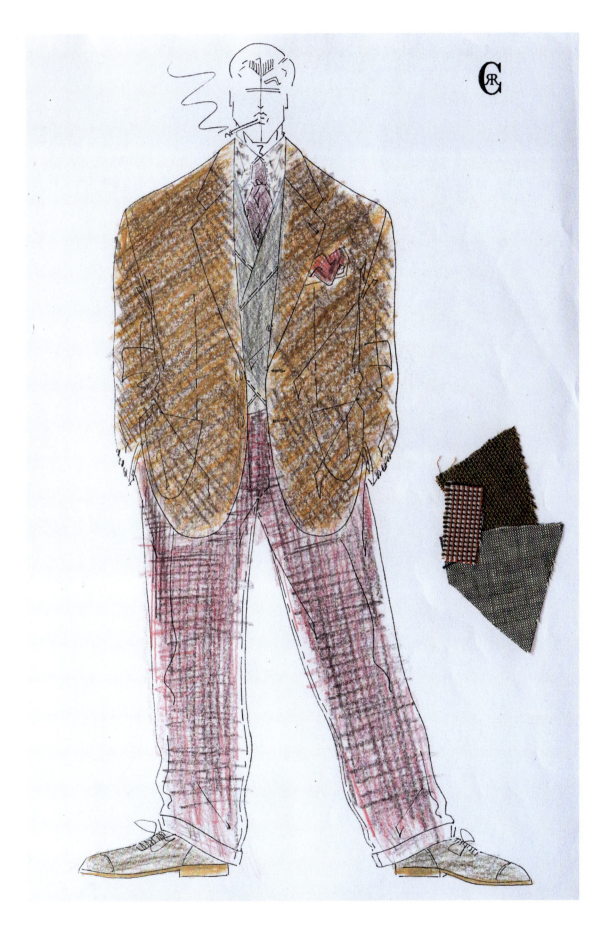

A menswear sketch for the Fall/Winter 1986 Ready-to-Wear Collection. Power dressing surpassed its trendsetting status to become a force in fashion in and of itself, yet held equal court with a hugely relaxed way of being.

Spring/Summer 1985 Ready-to-Wear Collection for women

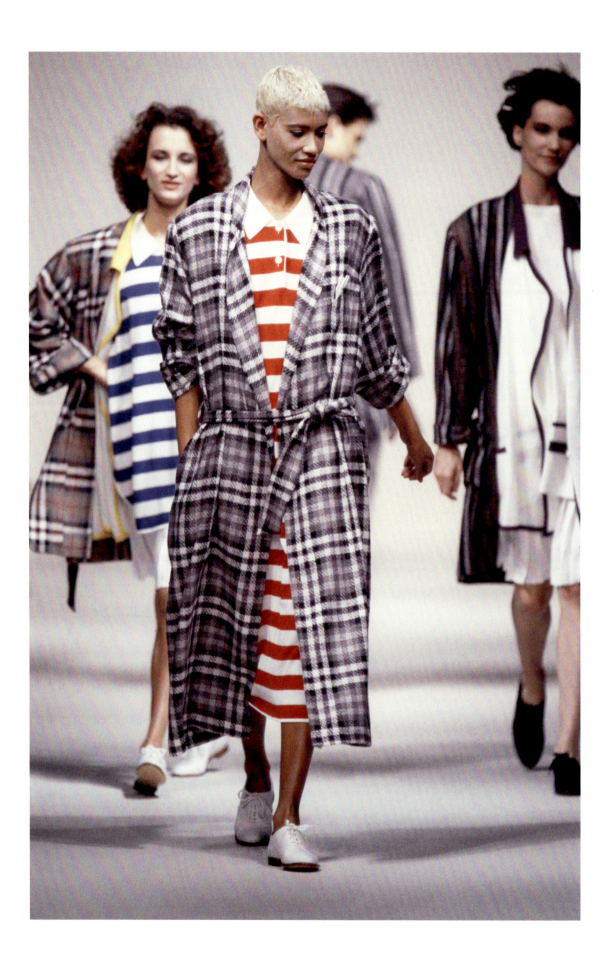

Below:
**New looks for women,
Spring/Summer 1990
Ready-to-Wear
Collection**

But there was a throughline with Cerruti's work. Despite designer labels now being ubiquitous, he refused to jump on board a train he saw as somewhat insincere. He was a designer, and needn't do more than create. In an age where the flash of a logo on a bag or a blouse meant you'd arrived, he knew he was already there. When looks mattered to so many, Cerruti realized that it was the substance they paid for.

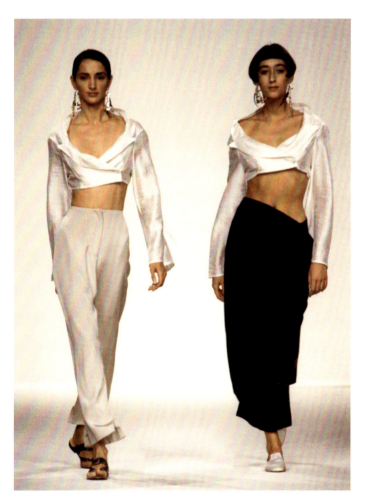

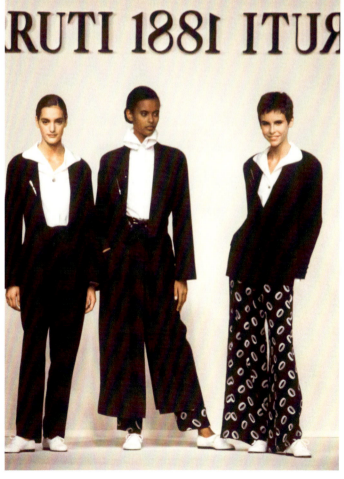

A Return to Understated Elegance

Fashion made a turn toward minimalism in the Nineties, albeit with a mélange of decades prior composing the looks that came down the runway. Clothes were posh again and the kitten heel and fitted suit made a comeback. Men and women were both enjoying the economic uptick in society, with a stock market that rode the Eighties wave, boosting spending power and consumption, while at the same time taking an anti-conformist stance to it all. Grunge defined the fringes, Hip-Hop came into its own, and the slip dress, gently, slipped right in with a trend that made underwear allowable in public.

Cerruti delighted in these designs, and reveled in the sexy and sleek of it all. His work easily adapted to the times, no matter the favor or forecast. Cerruti reached yet another level of fame when he hired Narciso Rodriguez, a designer who would soon be a household name after designing the wedding dress for Caroline Bessette to marry John F. Kennedy, Jr. in 1996. The sheath, crafted from pearl-white silk crepe, became a model for Nineties simplicity and elegance.

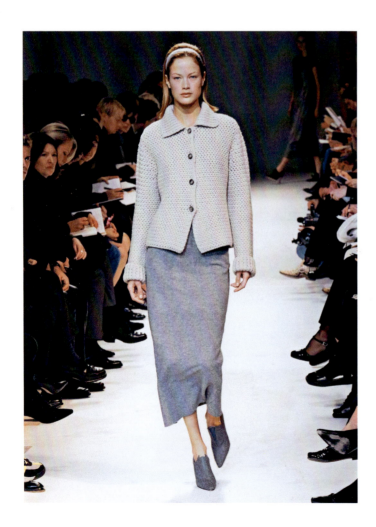

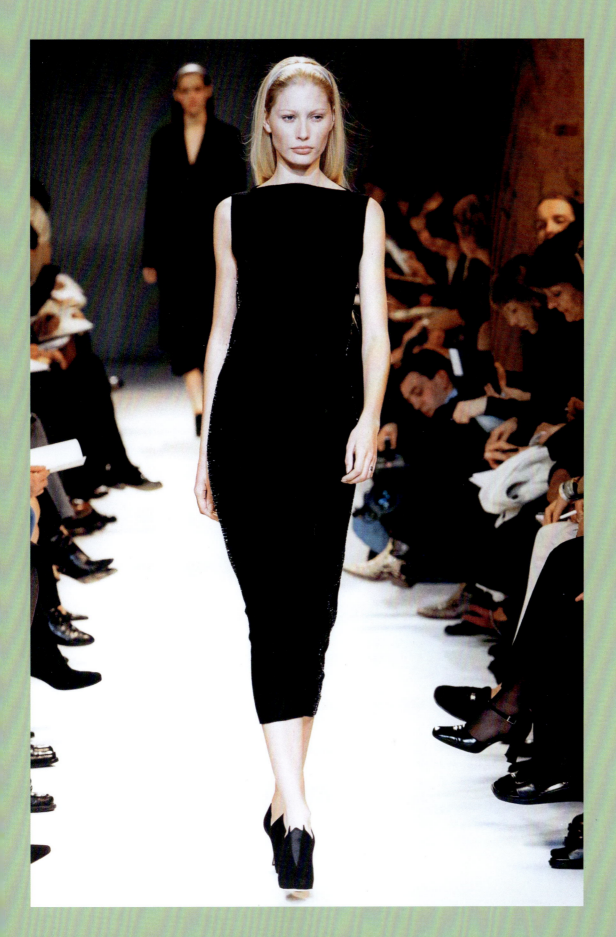

Opposite page and this page: New slimmer silhouettes for the Women's Fall/Winter 1998 Ready-to-Wear Collection

Menswear returned to more European roots, and Cerruti shined in this spotlight. An international culture had firmly taken hold with a jet set society that could take the Concorde from New York to Paris for lunch if they wanted to. Looking the part helped to up one's cool quotient—yet understatement ruled, always.

At right: New suiting in muted gray dominated the runway at the Men's Fall/Winter 1996 Ready-to-Wear Collection.

Opposite page: A traditional trench paired with a Cerruti suit for the Men's Fall/Winter 1996 Ready-to-Wear Collection

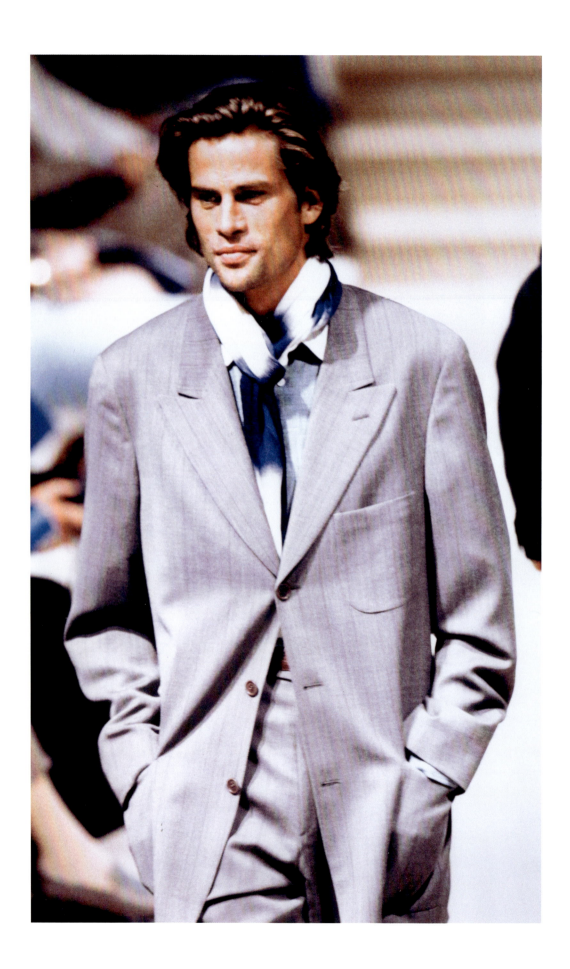

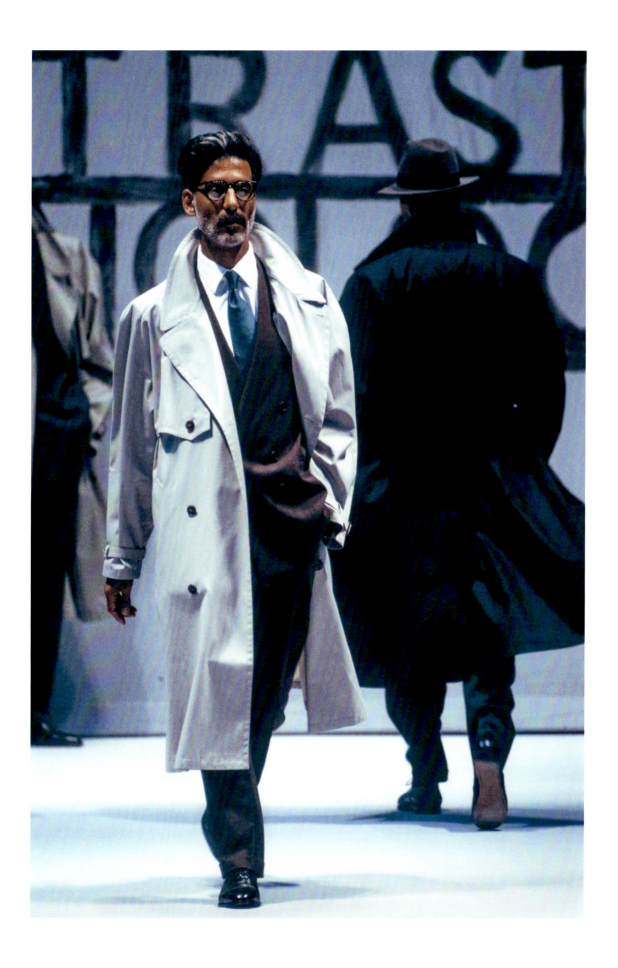

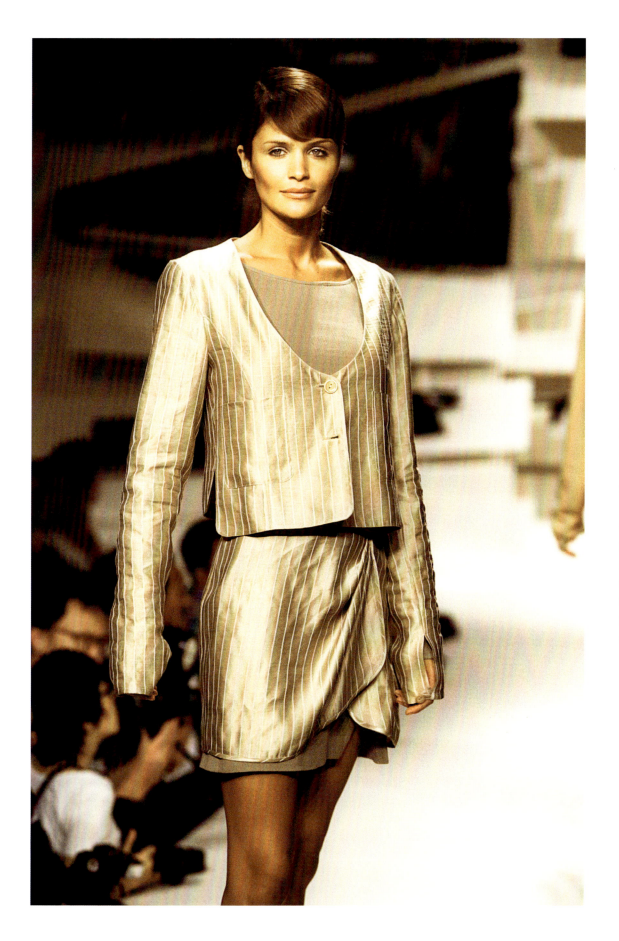

Opposite page: A casual, carefree day look for women, Spring/Summer 1990 Ready-to-Wear Collection. Cerruti assessed each show, planning the next with notes kept from past collections, a sign of his rigorous work ethic.

At left: Supermodel Helena Christensen walks the runway in a Cerruti suit, Spring/Summer 1995 Ready-to-Wear Collection.

Next page: The schedule of models, presenting the Spring/Summer 1997 Ready-to-Wear Collection

1. KATE
2. GUINEVERE
3. CAROLYN
4. JOLIJN
5. DANIELLE
6. IRIS
7. NAOMI
8. CHRISTINA
9. JENNY
10. STELLA
11. GEORGINA
12. CHANDRA
13. KYLIE BAX
14. ESTHER
15. ERIKA
16. TANGA
17. ASTRID
18. RHÉA
19. KATE MOSS
20. ELISABETH
21. KIRSTY
22. LANA
23. AURELIE
24. CHANDRA
25. CAROLYN
26. IRIS
27. STELLA
28. GEORGINA
29. TASHA
30. KYLIE BAX
31. AMY
32. RHÉA
33. KIRSTY
34. ESTHER
35. DANIELLE
36. TANGA
37. CHRISTINA
38. EMMA B.
39. CHANDRA
40. NAOMI
41. STELLA
42. KIRSTEN O.
43. AMY
44. TASHA
45. CAROLYN
46. ELISABETH
47. LANA
48. GUINEVERE
49. JENNY
50. ERIKA

And Then There Was the Yellow Sweater

For a man who made clothing and could afford to buy new if he needed, Cerruti stayed true to one garment in particular: His yellow cashmere sweater. It was much more than something he threw on to keep warm. It was his uniform, more or less, a piece he wore for nearly every show, either in total or draped around his shoulders. "He had maybe only three throughout the years. When he had new things, they would usually sit in his closet for a long time," said his son Jullian. His sort-of good luck charm, Cerruti's yellow sweater was a classic garment that represented the same timeless approach he put into everything he made.

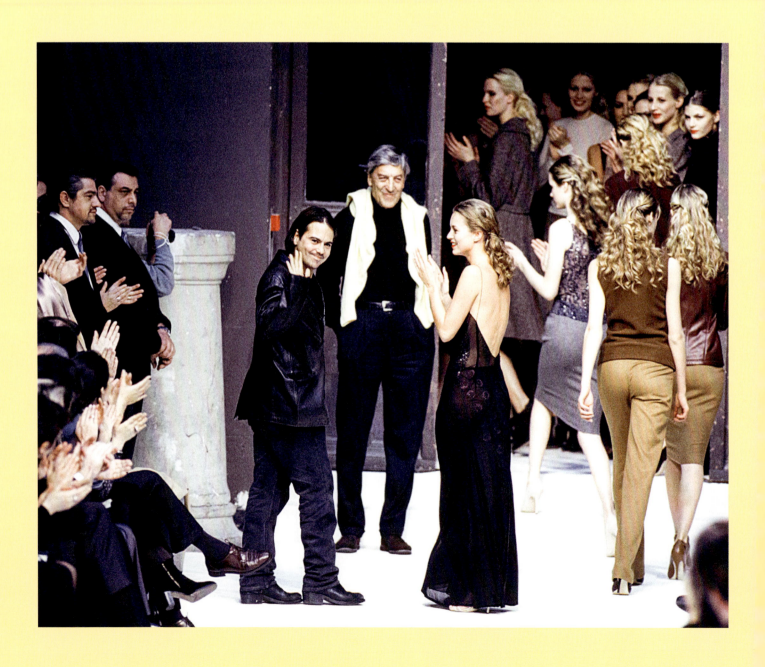

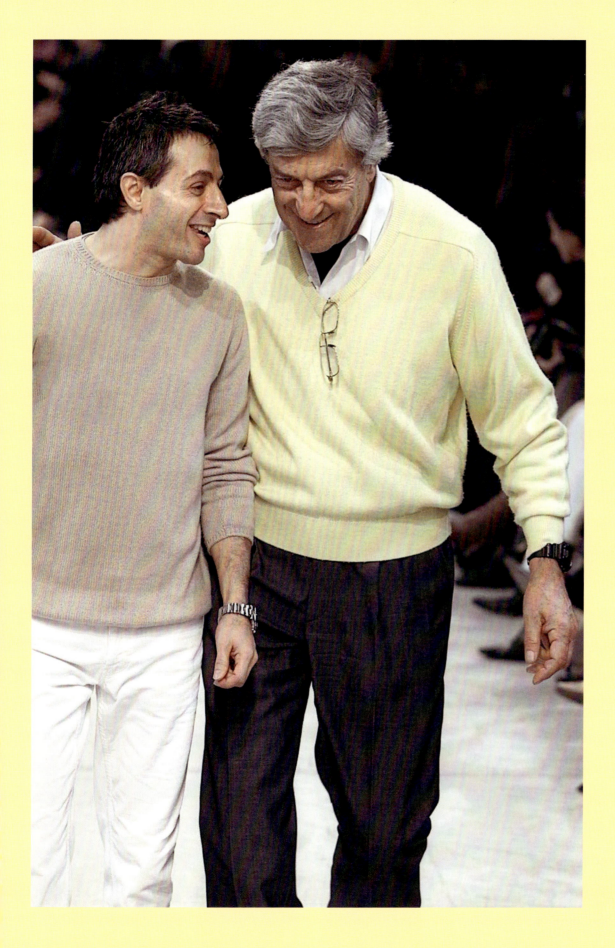

Nino with Peter Speliopoulos, Creative Director at Cerruti Arte from 1997 until 2002

**Left page:
Nino with his iconic yellow sweater at the end of the Fall/Winter 1998 Ready-to-Wear Collection**

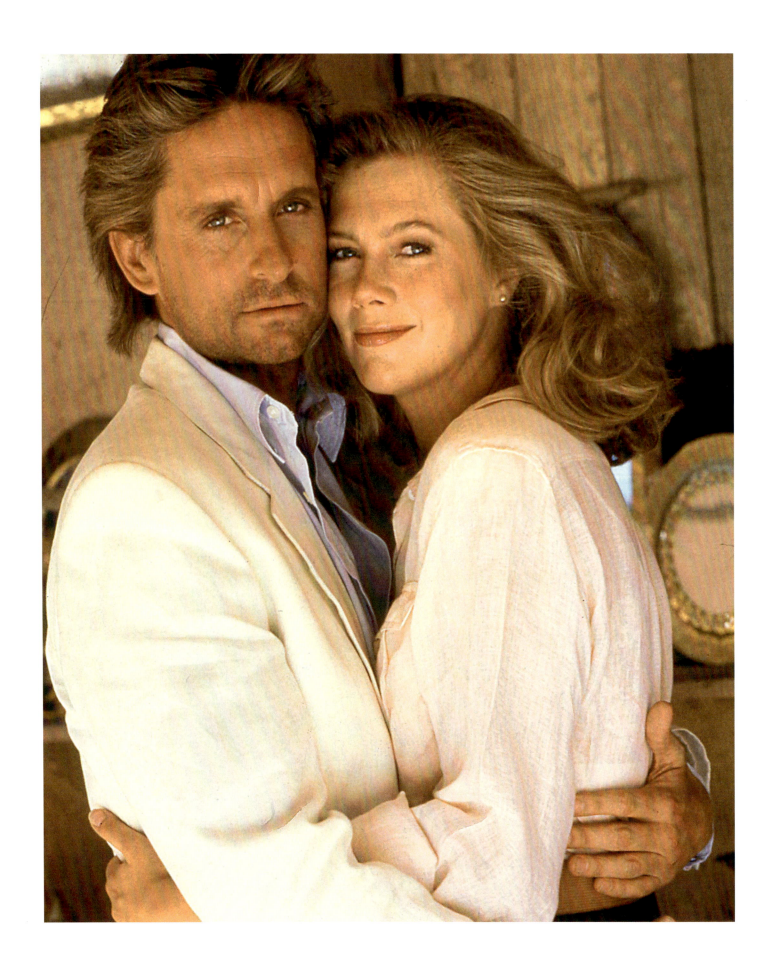

Esprit

In the 1960s, Hollywood film crews would travel to the Eternal City–Rome–to film iconic movies on location, and often at Cinecitta Studios there. The American actors starring in the films were taken with the Cerruti clothes sported by Italian film crews, so chic was their appearance. With the many movies made on European soil during the 70s, 80s, and 90s, Cerruti's popularity only flourished.

Early on in his career, Cerruti had dressed Faye Dunaway for the 1967 hit film *Bonnie and Clyde*. It was his first endeavor into providing costumes for the big screen, and two decades later, it would skyrocket: Starting in the late Eighties, Cerruti started dressing the major stars of both Hollywood and French cinema. His clothes appeared in over 150 films.

The clothing Cerruti fashioned was as much of a character in the films as the characters were. Every power suit, every silk blouse, every skirted ensemble, every single T-shirt and Bolero was a turning point for the characters.

Who else, then, to outfit the titans of Eighties and Nineties Hollywood, Michael Douglas and Kathleen Turner? The film greats wore Cerruti on and off screen, with the clothes solidifying their characters in the minds of filmgoers everywhere.

Jewel of the Nile (1985),
**Michael Douglas
and Kathleen Turner**

**Next page:
Faye Dunaway wears
a Cerruti suit in 1967's
Bonnie and Clyde opposite
co-stars Warren Beatty
and Gene Hackman.**

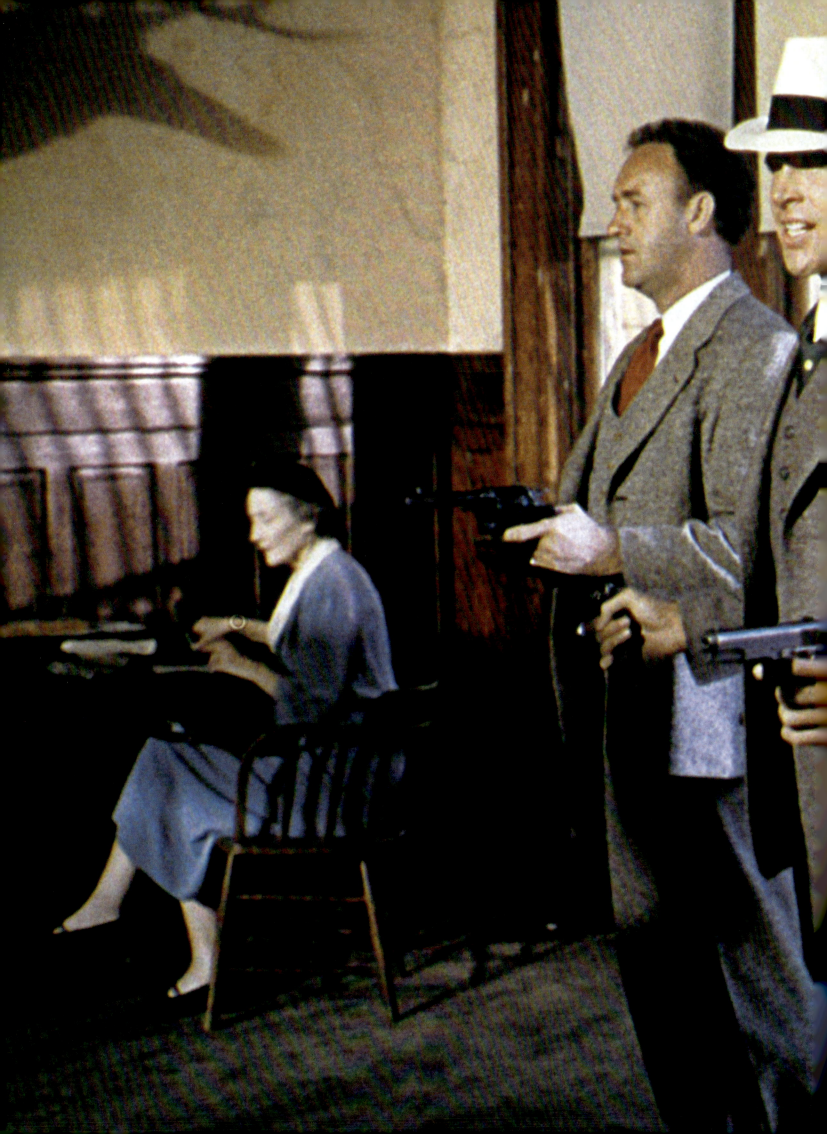

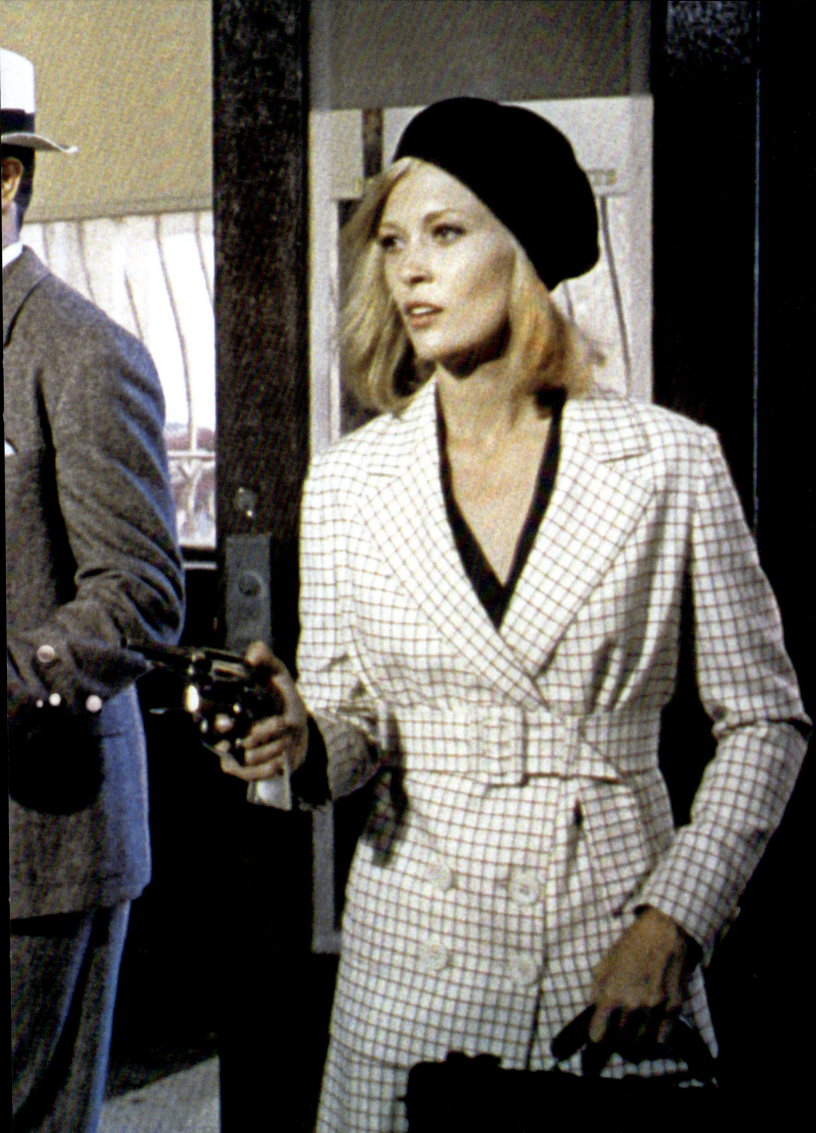

Basic Instinct
(1992) with stars Sharon Stone and Michael Douglas

"Clothes are important for an actor, they help his performance and certain materials can completely change your whole attitude," said Michael Douglas. "In this film, I wear Cerruti suits, and I wear suspenders. They're an article of clothing that helps to define the role because my character on the inside was so decadent; on the outside, he had to feel like he was clean."

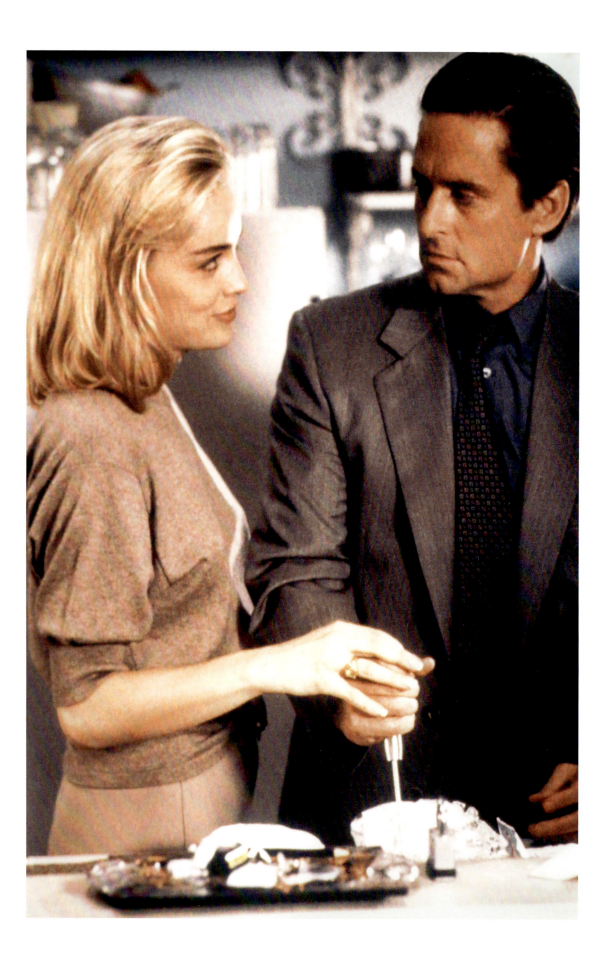

Why am I chosen so often? I think it's because I don't try to substitute my wishes or taste for those of the actor. I adapt to the needs of the film and I am flattered when a costume designer decides that my work will fit with what they want to achieve.

Nino Cerruti

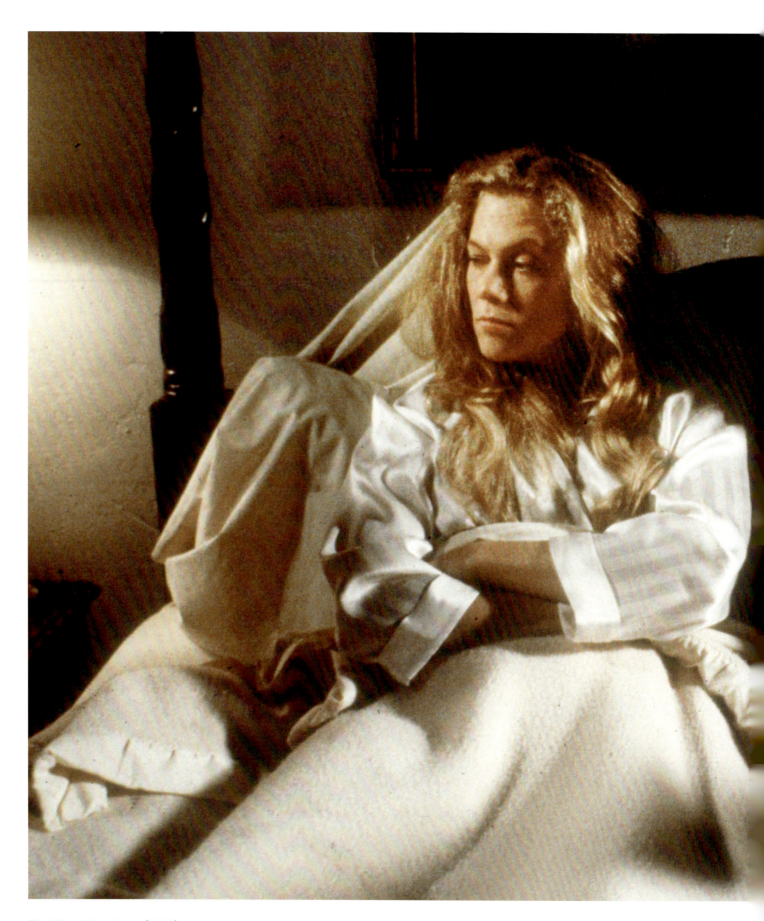

The War of the Roses (1989)

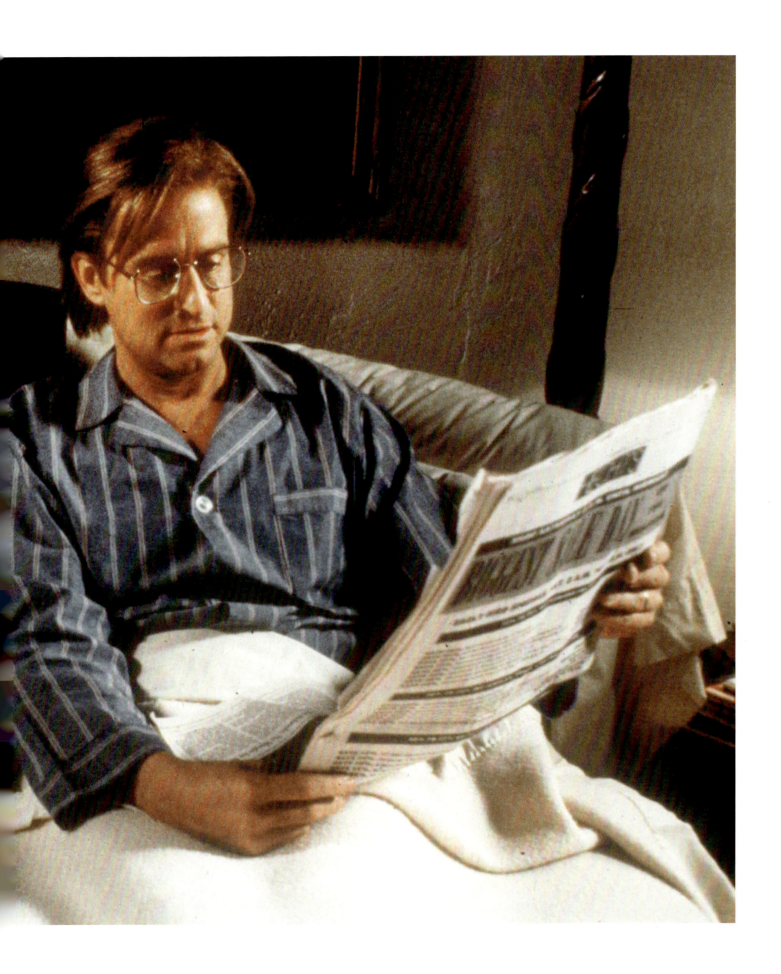

"Nino contacted me when I was visiting Paris. He was an extraordinarily charming man and impeccably dressed. He showed me his workplace there and the lovely fabrics and styles. His clothes were a huge inspiration for my characters," Kathleen Turner said. "I was so grateful to him for designing an evening gown for me when I was pregnant and wore it at the Venice Film Festival."

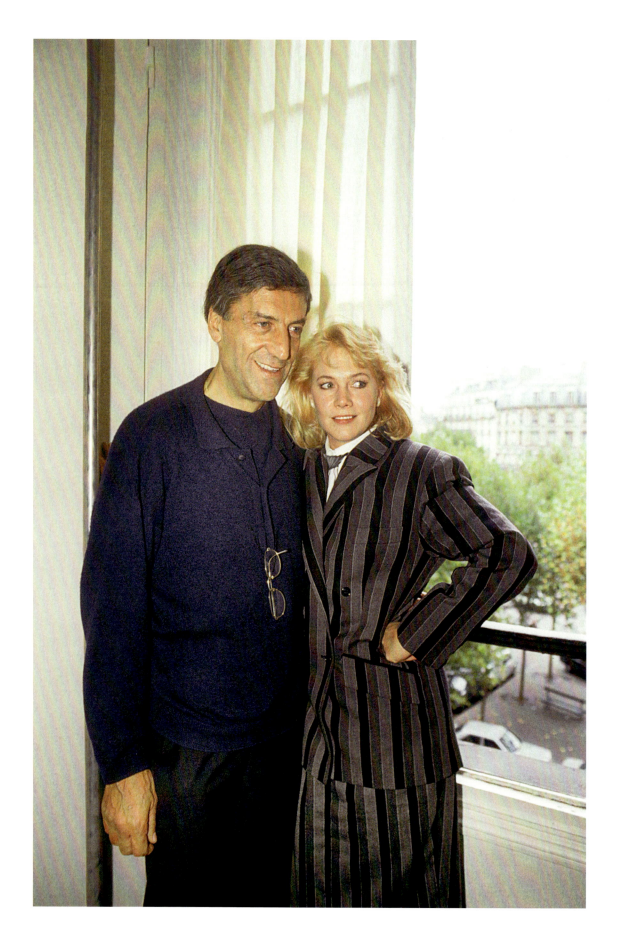

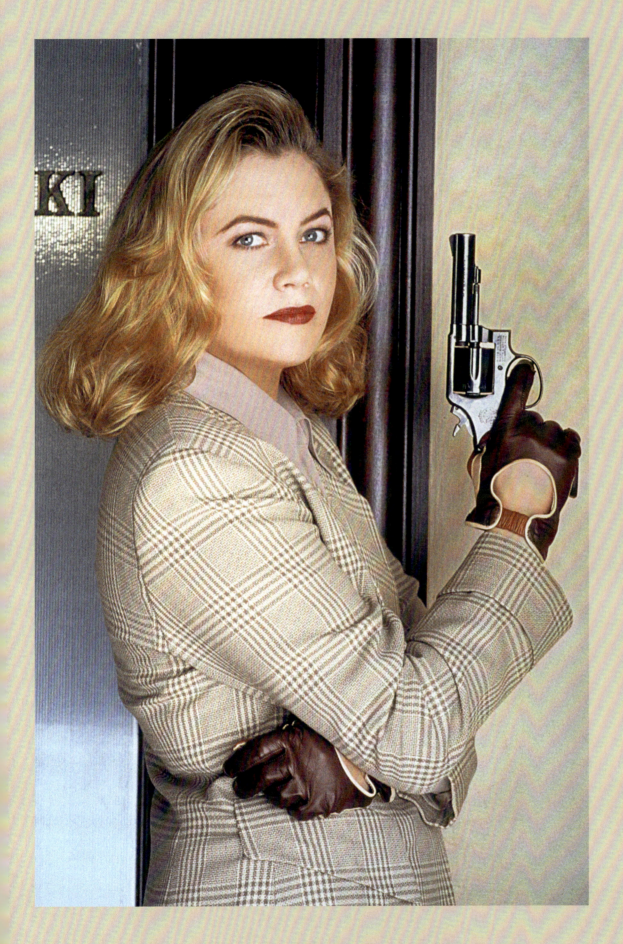

V.I. Warshawski
(1991)

Cerruti considered Kathleen Turner his "muse" and the two developed a fast friendship. She found his pieces luxurious and perfectly fitted, ideal beautiful clothing to wear.

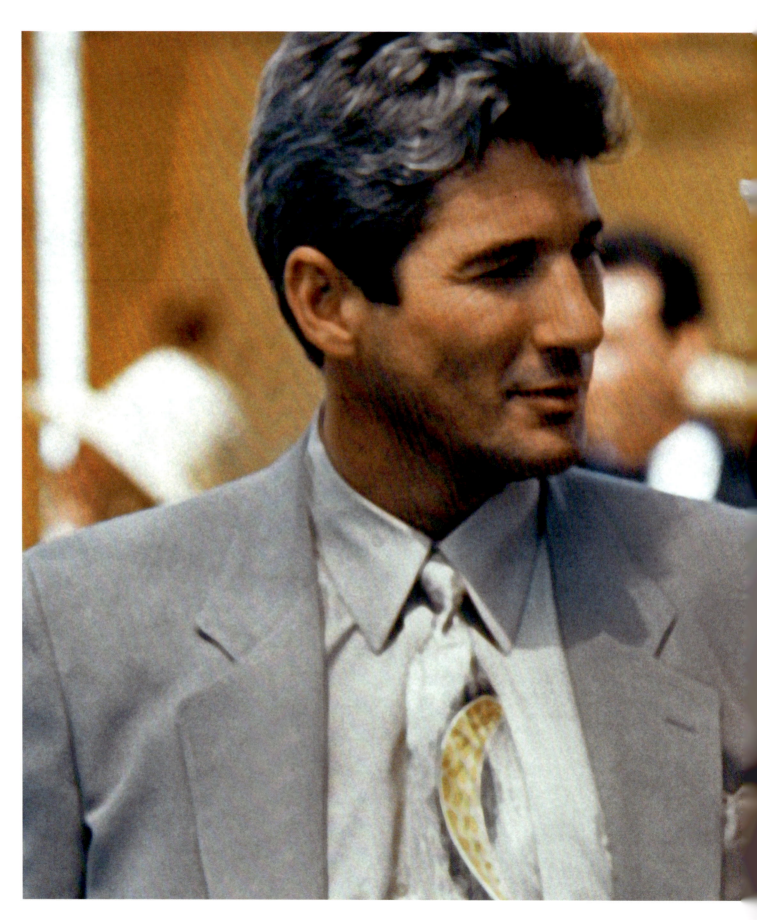

The unforgettable characters of businessman Edward Lewis, played by Richard Gere, and lady of the evening Vivian Ward, played by Julia Roberts, in *Pretty Woman* (1990) were made even more so as a result of Cerruti's expert costuming. Gere's prosperity jumped off the screen in Lewis's

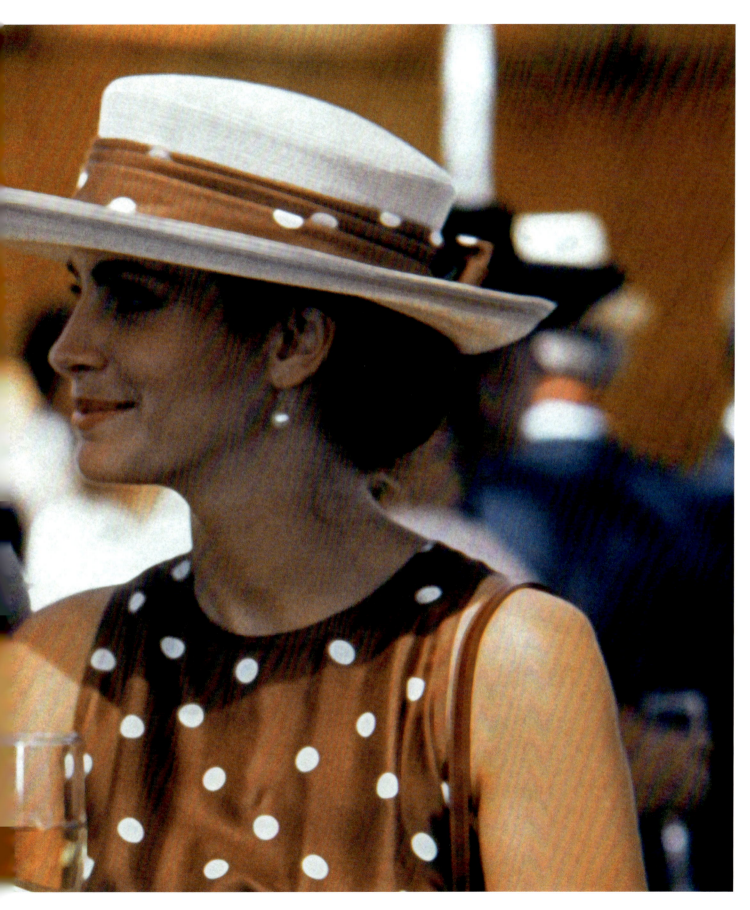

relaxed yet sophisticated suiting and Roberts' polka dot dress
became a sartorial anthem for American women everywhere,
whether upwardly mobile or merely in search of a time-honored classic.
Cerruti fashioned this one in a soft brown with white polka dots.

FBI chief Jack Crawford, played by Scott Glenn, looks the perfect part in a Cerruti brown overcoat, among other pieces, in the film that riveted audiences, *Silence of the Lambs* (1991).

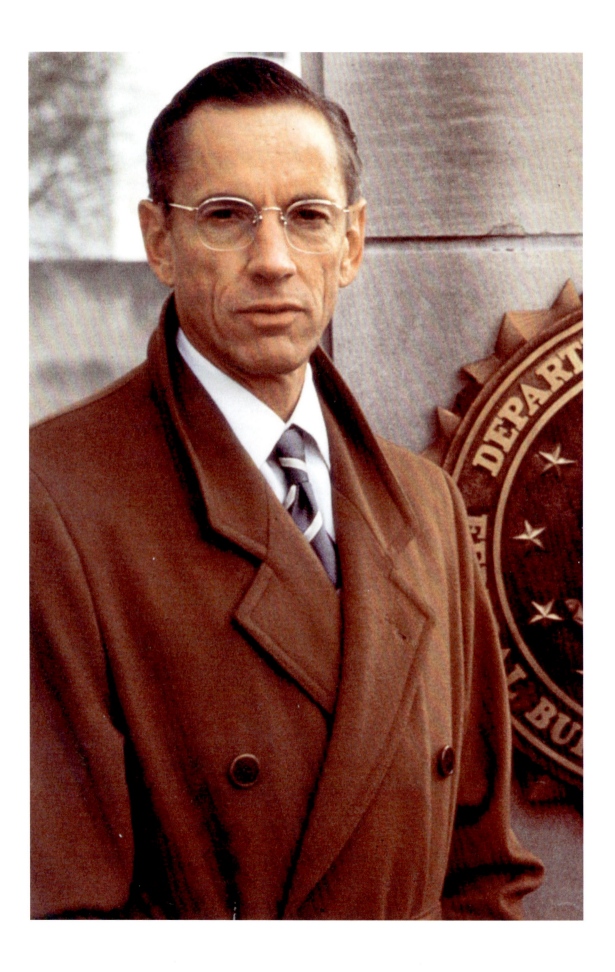

To create memorable characters, one needs a perfect silhouette, and Nino was the master.

*Ellen Mirojnick,
Hollywood costume designer*

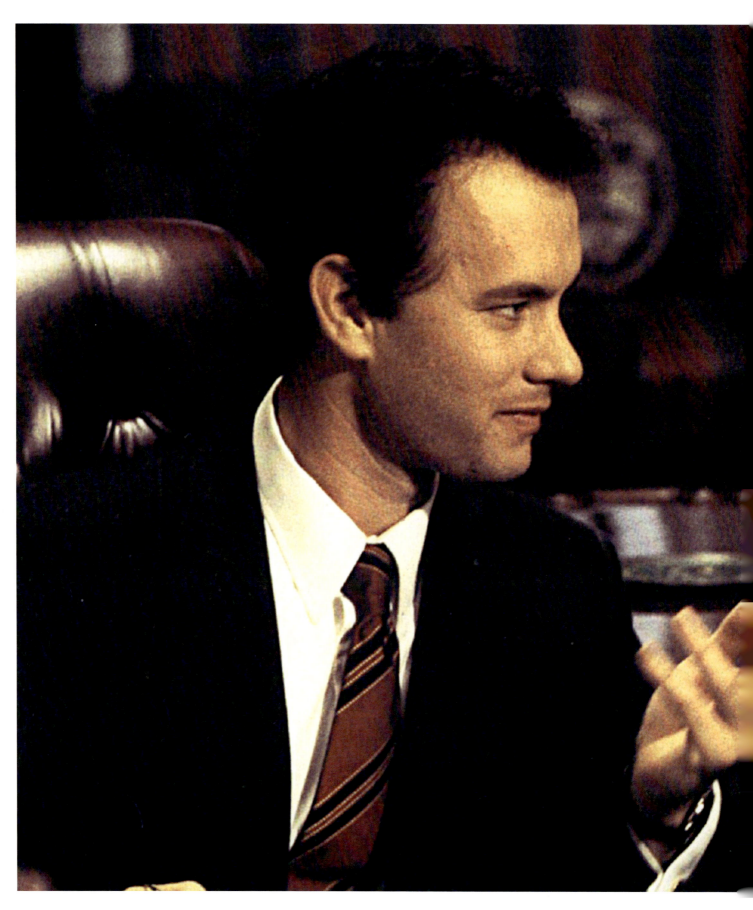

Many fashion houses of the day refused to have their name linked to the 1993 film *Philadelphia* but not Cerruti. The designer dressed Tom Hanks for his star turn as Andrew Beckett, a lawyer who is forced to resign from his law firm after it's suspected he has AIDS. Hanks won the Academy Award for Best Actor for his role in the film.

Action heroes are why some people go to the movies, and Cerruti made megastars that much more compelling, including Bruce Willis, in *Die Hard II* **(1990) and** *Hudson Hawk* **(1991) as well as Harrison Ford in** *Clear and Present Danger* **(1994) seen here at left.**

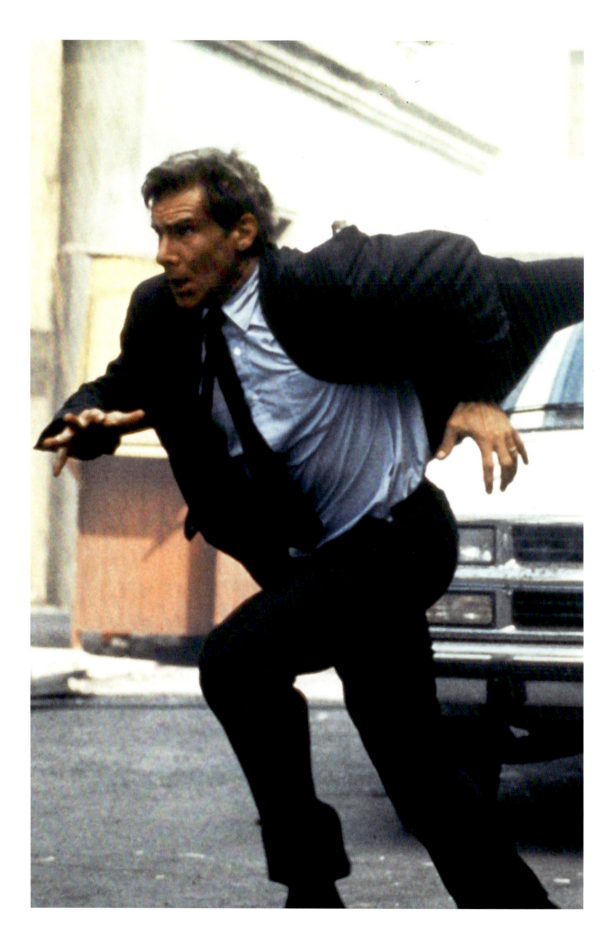

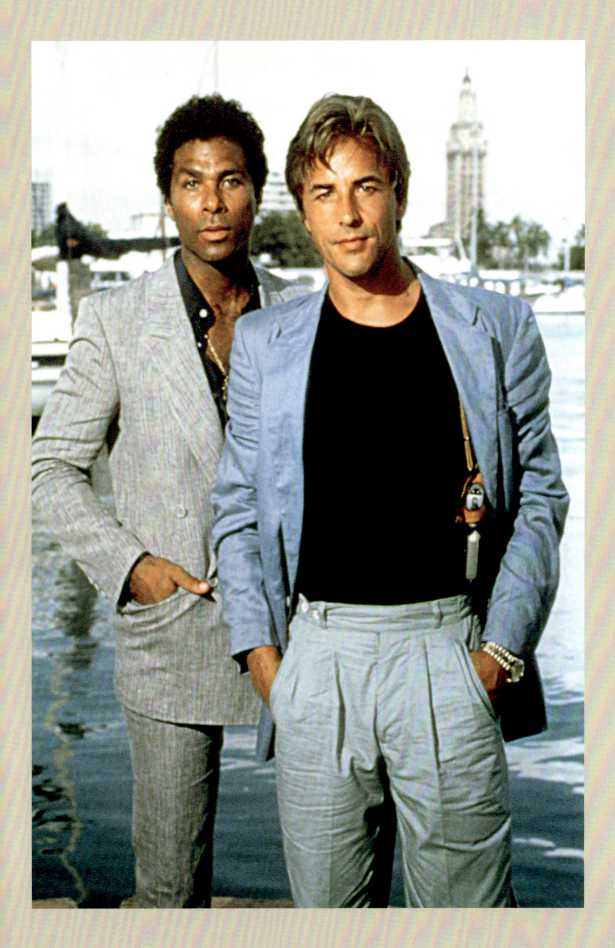

Who could forget Don Johnson and Philip Michael Thomas in the iconic Eighties television series *Miami Vice*? Cerruti was the first designer to show on screen the unorthodox pairing of a T-shirt with a suit and athletic or casual shoes. It became one of the looks of the decade, imitated far and wide, and made megastars of the show's protagonists.

Cerruti dressed Jeremy Irons' character Claus von Bülow in the thriller *Reversal of Fortune* (1990) in his requisite tuxedo and silk robes.

Dressing bad guys wasn't out of the question. Who but Jack Nicholson could play the Prince of Darkness, outfitted so devilishly by the master of Italian fashion, in *The Witches of Eastwick* (1987).

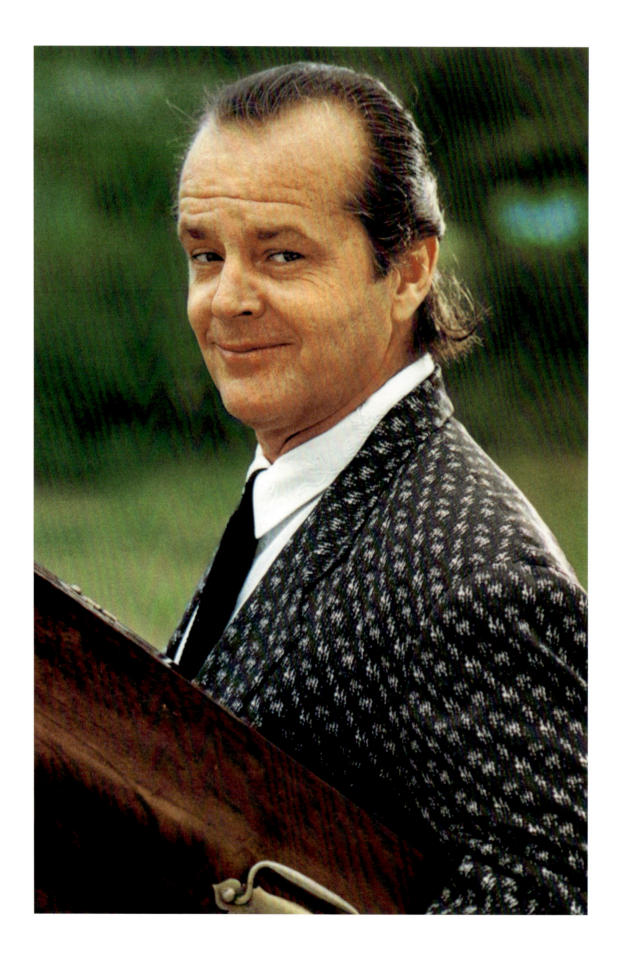

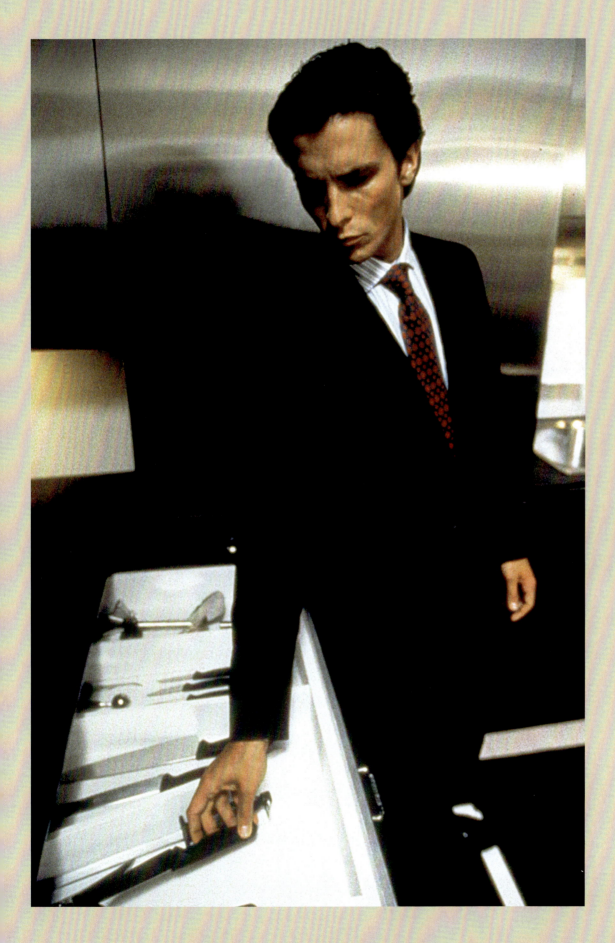

Christian Bale's breakthrough hit, *American Psycho* (2000) launched the actor into stardom as a result of his serial-killer-banker character Patrick Bateman wearing a Cerruti suit. "Most fashion houses saw it as a negative to be linked to the film," says Julian Cerruti, remembering the outcry about the movie adaption of Bret Easton Ellis' already scandalous novel. "Not Nino. His suits made that character."

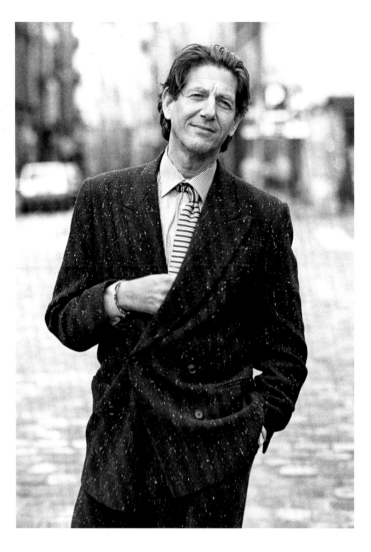

At left:
The actor Peter Coyote dressed in Cerruti for the Cerruti 1881 fragrance advertising campaign, 1993.

At right:
Cerruti and Coyote enjoying a laugh at the Cafe de Flores in Paris, 1993.

One of Cerruti's most cherished relationships in Hollywood was that with Peter Coyote. The actor had just turned 50 and was at a turning point in his life. Cast in a new movie in 1992 by Roman Polanski, *Bitter Moon*, was a tale of twisted love and fatal encounters.

"I went to Roman's house in Paris for a first meeting. Nino Cerruti was there, just sitting in the corner. We were watching the end of the Tour de France and Roman turned to me and said, 'Here are the best cyclists in the world crossing the finish line 1/100th of a second apart. Can you imagine what concentration and effort that takes? That's what I want from you.' And I said, 'OK I'm going to go talk to that guy in the corner.'

Nino and I started chatting and he said, 'Peter, what are your plans for your life?' When he asked me this, I fell apart. I had just gotten divorced. I was in Paris, I had no idea what my life was about. And so I made this kind of confession to him. I was really naked about everything, and instead of being embarrassed, we became friends.

"He gave me a lot of information about how to move through Europe. I was five years out from being a heroin addict and living in the counterculture, and I needed it.

"He then asked me to model in his shows, and at the end of them, he would say, 'Take what you like!' To this day, I have eight Nino Cerruti suits and they are perfect. I've never lost a button."

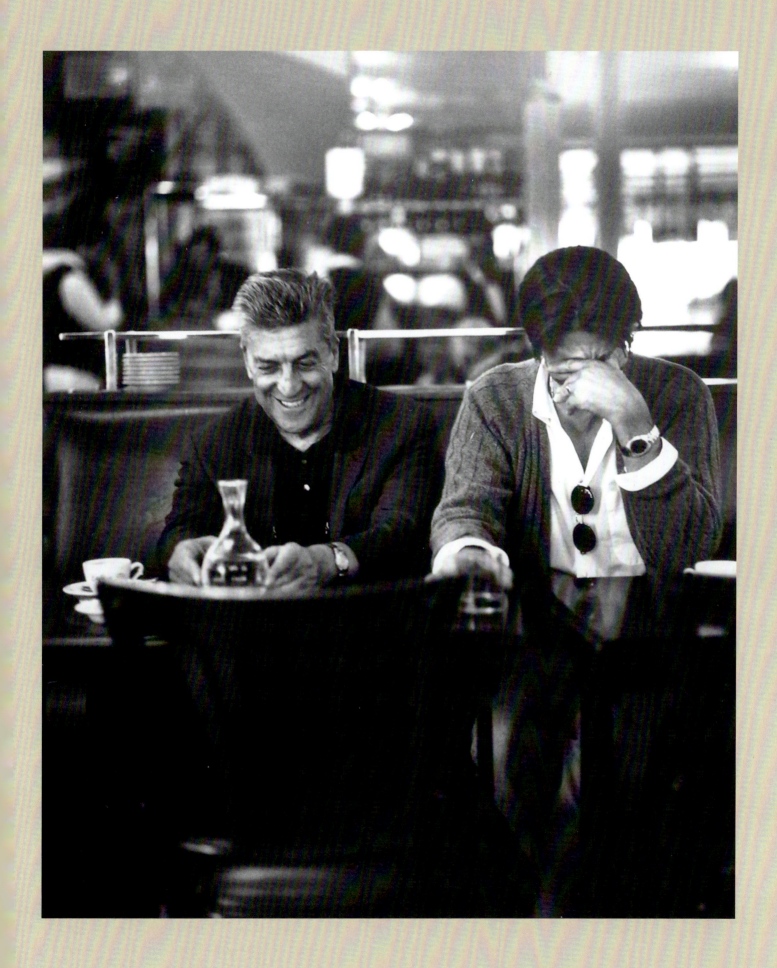

I love actors. They are never conventional. They are enthusiasts and their enthusiasm is contagious.

— Nino Cerruti

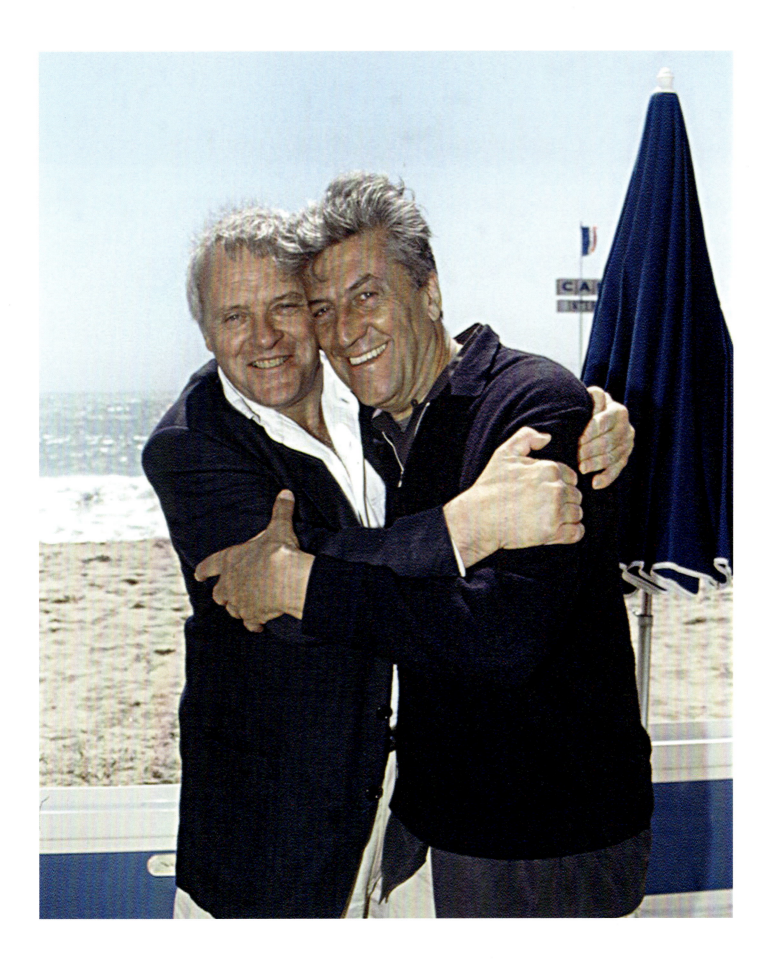

Previous page: Cerruti with his friend, actor Sir Anthony Hopkins, in Cannes, May 1994.

At right: French film sensation Jean-Paul Belmondo strikes his usual pose.

Opposite page: The movie poster for the 1976 film *Mr. Klein* starring French actor Alain Delon, who wore the Cerruti classic chocolate brown manteau for the lead role.

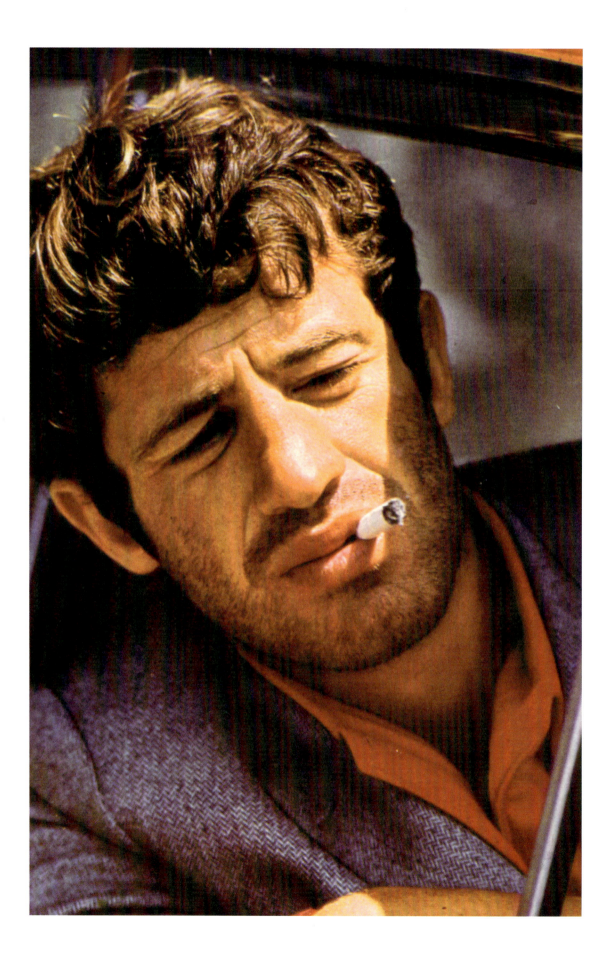

On French Shores

As a resident of Paris, it was a natural for Cerruti to become involved in France's film industry as well, and dressing Jean-Paul Belmondo meant he had reached the zenith. The undisputed king of French cinema, "Bebel" as the French called him, was no less than a national treasure in France. Cerruti dressed him as the delinquent Francois Cappella in 1970's *Borsolino* and in *Ho!* in 1968. The actor Philippe Noiret, whom Cerruti dressed for the film *Max et Jeremie* (1992) and who became a good friend, said "Nino Cerruti is a man of culture and distinction. When he dresses you for a film, you can count on him for suggestions, details, precise and accurate advice that will help you as an actor to perceive your character more minutely."

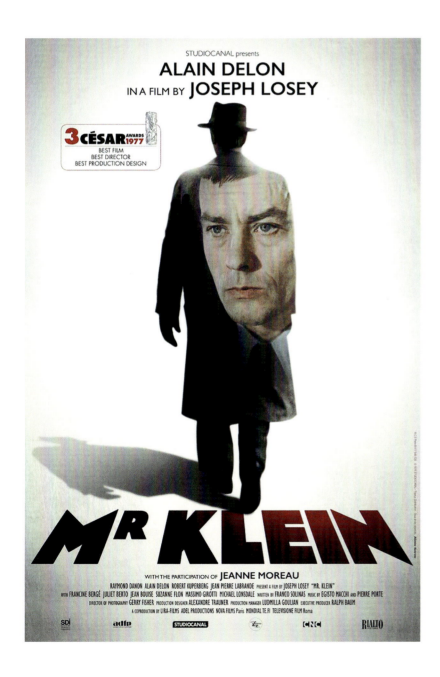

Gérard Depardieu wears Cerruti in *La Machine* (1994).

Cerruti dressed Catherine Deneuve and Yves Montand in *Le Sauvage* (1975). He remained friendly with the actress for many years afterward.

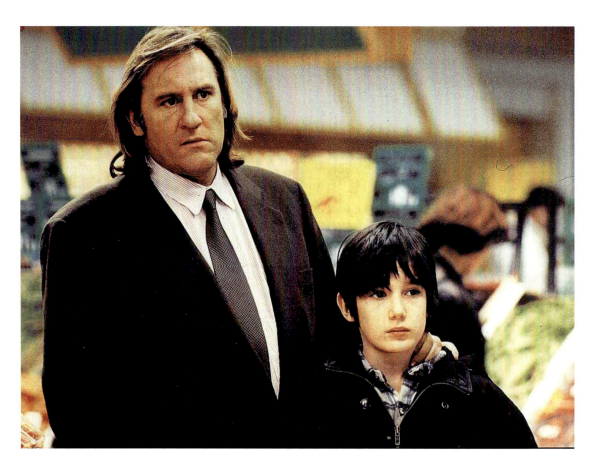

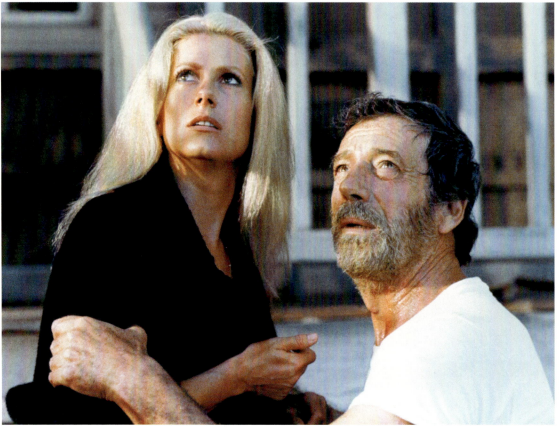

I don't try to make a fashion show, I try to define a character. But if you love films, you should never go on the set! You can't shatter your illusions. Regular guys need to dream, don't they?

Nino Cerruti

The Stuff of Legend

As sportswear became a category of clothing in and of itself in the 1970s, Cerruti took to the trend rapidly and added sportswear collections to his lines. It was a concept he ran with, and it would push his visibility even higher.

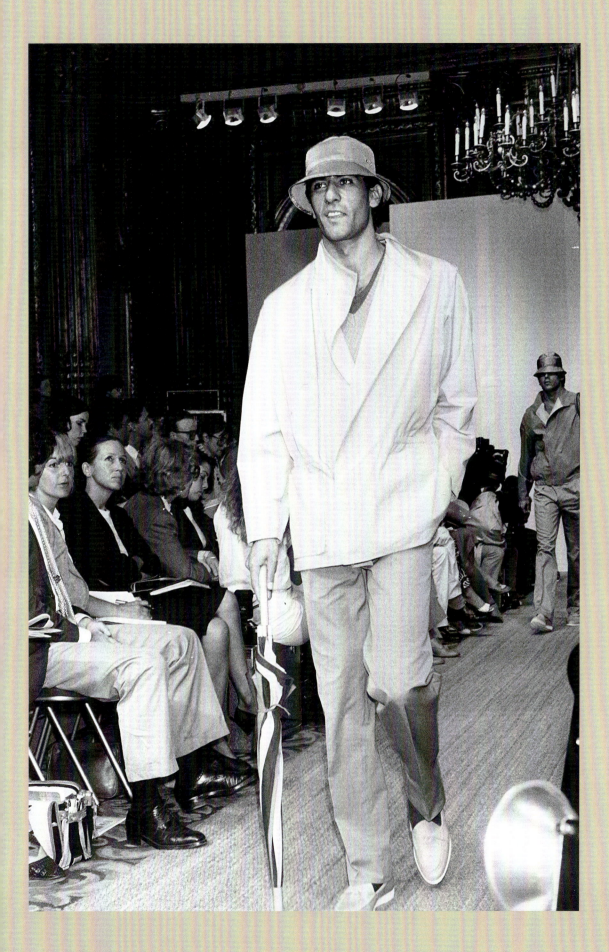

At left:
A model walks the runway in new sporty looks of the season for the Spring/Summer 1992 Collection.

Opposite page:
A 1970s Cerruti tracksuit in cool aqua blue

Cerruti had the novel idea of actually using major sports figures on his runways: In 1996, he asked footballer David Ginola to walk his shows in Cerruti designs. Ginola agreed and signed a modeling contract with Nino Cerruti while he was still playing with Paris Saint-Germain and presented the Spring/Summer Prêt-à-Porter Homme collection by Cerruti in Paris.

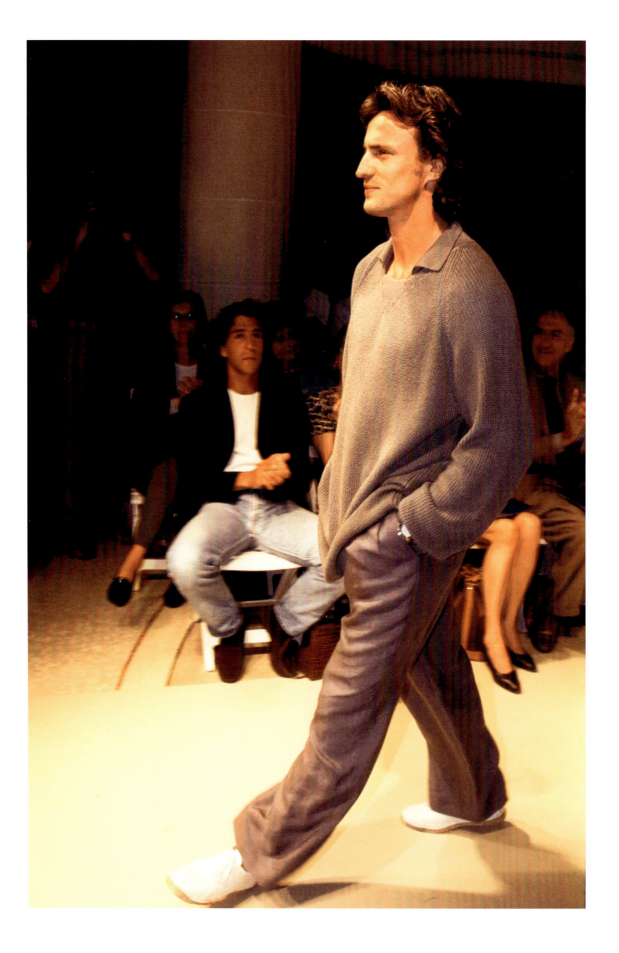

Press clips documenting the media buzz surrounding David Ginola's cooperation with Cerruti

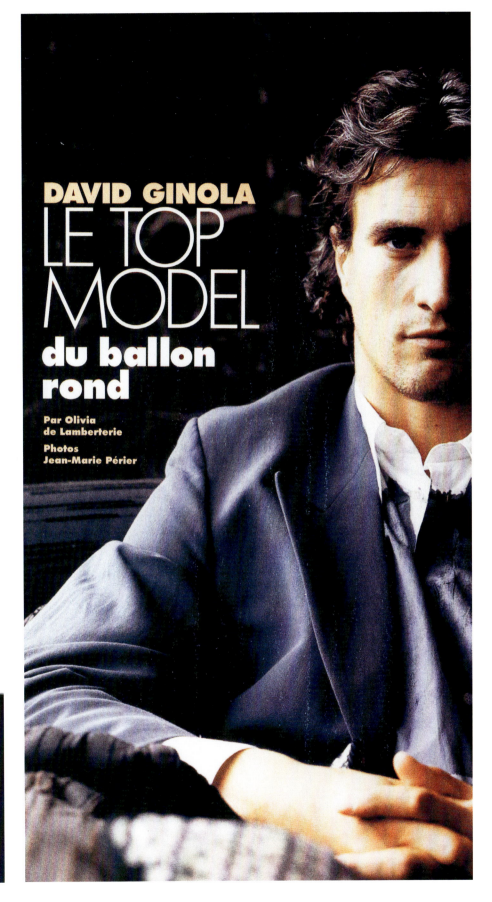

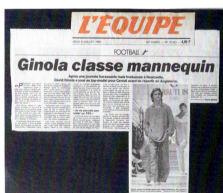

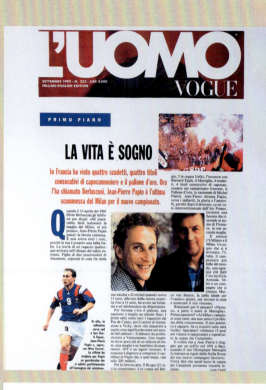

INTERVISTA: JEAN PIERRE PAPIN

ELEGANTE A TUTTI GLI STADI

A suo agio come indossatore e come star del pallone. Testimonial dello stile Cerruti, Jean Pierre Papin confida sogni, progetti e segreti: e afferma che tra calcio e moda c'è un filo conduttore. L'eleganza

di Antonio Mancinelli

«Nobile semplicità e quieta grandezza». Forse Jean Pierre Papin non conosce la definizione della classicità offerta da Winckelmann, ma senza dubbio il suo comportamento, fuori e dentro lo stadio, tende a una tranquilla, serena consapevolezza di essere il più bravo di tutti. Simpatico, sorridente, affabile nel rispondere alle domande quanto paziente nel firmare autografi ai festanti tifosi, per Papin il successo è una specie di dolce condanna a cui si assoggetta volentieri. Anzi, è un destino a cui sapeva di andare incontro fin da quando, adolescente, già convinto del suo valore calcistico, giocava nei campi della Francia del nord. Nato a Boulogne sur Mer nel 1963, prima di essere acquistato a suon di miliardi dal Milan berlusconiano — dove gioca da centravanti — è stato quattro volte campione di Francia con il Marsiglia e ha vinto l'ultimo Pallone d'Oro come migliore calciatore d'Europa. E lui, placidamente, non lo ammette. Lo sa, e basta. Tanto da parlare di se stesso, qualche volta, in terza persona: come Giulio Cesare nel *De bello gallico*. Eppure non gli toglie alla sua gentilezza d'animo e al suo entusiasmo contagioso che irradiano da un sorriso sempre aperto e da un azzurro sguardo allegro. Testimonial dello stile Cerruti, si lascia vestire e fotografare con la docilità di un neofita, disponibile persino a rispondere a domande che riguardano un settore che sembra molto lontano dal suo: la moda.

Una volta i campioni sportivi erano immuni da frivolezze. Oggi c'è chi si rifà il naso o cambia colore di capelli. Lei ha qualche 'debolezza' nell'abbigliamento?
Assolutamente no. Sono molto sobrio nel vestirmi e nella cura della mia persona. Soltanto quando gioco come capitano in Nazionale, porto al braccio un 'portebonheur': è la 'bandana' di mia moglie Florence, un oggetto a me caro, che finora mi ha portato molta fortuna.

Nelle sue apparizioni pubbliche lei indossa sempre capi di Nino Cerruti. Lo preferisce perché le piace o per un po' di sciovinismo, visto che lo stilista — anche se italiano — è francese per adozione?
Vesto Cerruti semplicemente perché amo il suo stile e porto sempre i suoi capi, anche in occasioni informali o non ufficiali. Sono stato molto contento quando, in Val d'Isère, ho ricevuto un premio per l'eleganza proprio dalle mani di Nino Cerruti.

Nello shopping sceglie il gioco 'di squadra' oppure no? Vale a dire: fa acquisti in compagnia o decide tutto da solo?
Mi accompagna sempre Florence: mi fido ciecamente di lei, che spesso compra per me anche gli accessori.

Trova un tratto comune tra moda e calcio?
Sì, senza dubbio: l'eleganza. E la spettacolarità, che non deve mai mancare in due fenomeni del genere.

Il suo hobby è vedere film. Possiede 2.500 cassette video: c'è un attore del presente e del passato che ammira in modo particolare e a cui ha pensato di ispirarsi per il modo di vestire, di parlare, di atteggiarsi?
Mi piacciono i film d'azione e gli attori che prediligo sono Michael Douglas, Mel Gibson, Robert Redford. Per quello che riguarda imitare qualcuno... sinceramente mi ispiro solo a Jean Pierre Papin. Se dovessi pensare di essere un'altra persona, avrei voluto diventare un chirurgo, per poter salvare le vite.

Lei è un uomo 'd'oro'. Berlusconi ha pagato molto per averla nel Milan. Come ha cambiato il denaro la sua vita?
Non l'ha cambiata molto. Piuttosto mi ha regalato la tranquillità per il futuro mio e dei miei tre figli, di otto, cinque e due anni. La serenità e il non avere problemi di nessun tipo sono obiettivi che mi sono sempre proposto di raggiungere: e spero di esserci riuscito.

Sogni nel cassetto?
Vincere la Coppa dei Campioni: un sogno che mi sembra adesso abbia molte possibilità di diventare reale. Per quello che riguarda la mia vita privata, sogno di avere un quarto figlio: e anche questo è un desiderio che può essere realizzato facilmente, vero?

Che differenza ha trovato nel suo trasferimento in Italia, tra le donne francesi e quelle italiane?
Le italiane sono sempre molto curate, ben vestite in ogni occasione. Le francesi amano di più la sobrietà.

E tra gli uomini?
Esattamente il contrario. In Francia vedo uomini molto 'habillé', azzimati: qui mi sembra che siano tutti più disinvolti, più a loro agio nei vestiti. Proprio come me.

An. Ma.

Testimonial di Cerruti 1881, Jean Pierre Papin indossa un abito principe di Galles nel nuovissimo Dribbling. Tecnicamente avanzato, di grande qualità e affidabilità, il tessuto prende nome proprio dal vocabolario calcistico. Per produrre un metro occorrono 25 km di filato e le fibre in lana sono legate da 30 milioni di spirali. Scarpe di Ugouomo, pallone Lotto. Foto di Danilo Frontini.

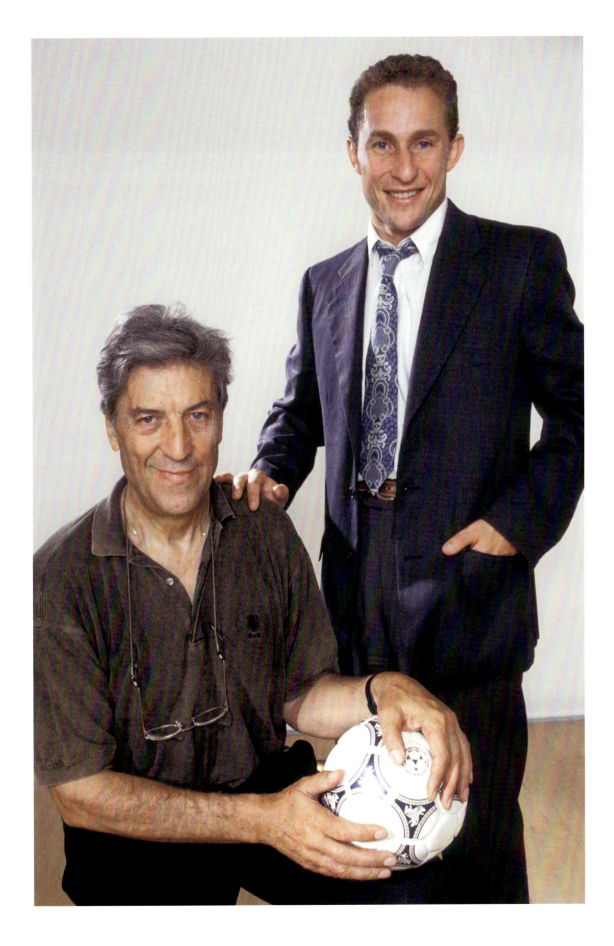

Cerruti signed on French footballer Jean-Pierre Papin as well. Both men received huge attention from the press throughout Europe. What was looked upon then as an anomaly—to have sports stars wear one's fashion line—and an odd business move by the industry caught on quickly and led to today's common practice of sports-star endorsements.

Cerruti then dressed the greats of tennis: U.S. phenom and eight-time Open champion Jimmy Connors wore the designer's clothes for many a match.

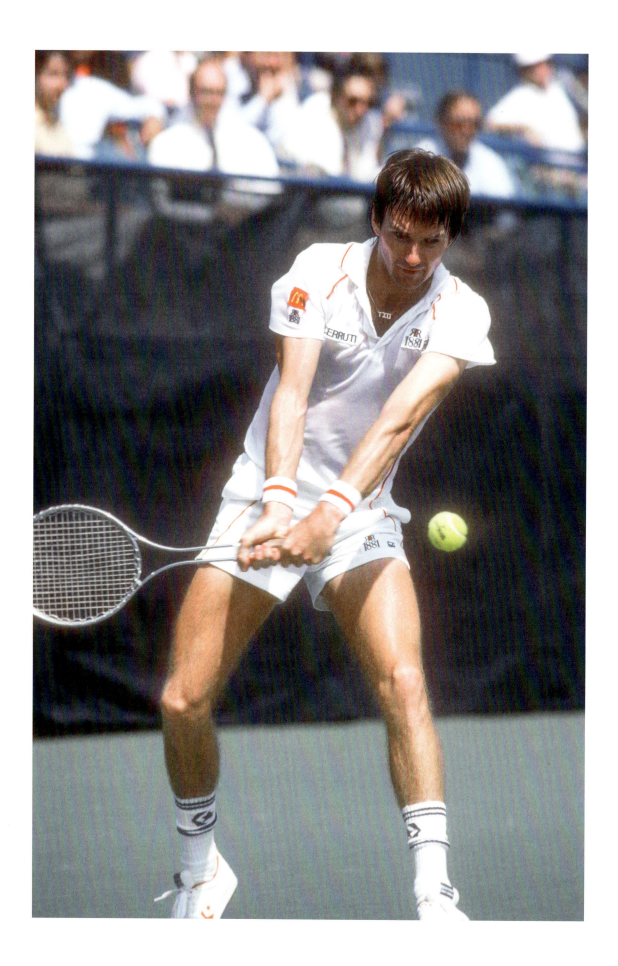

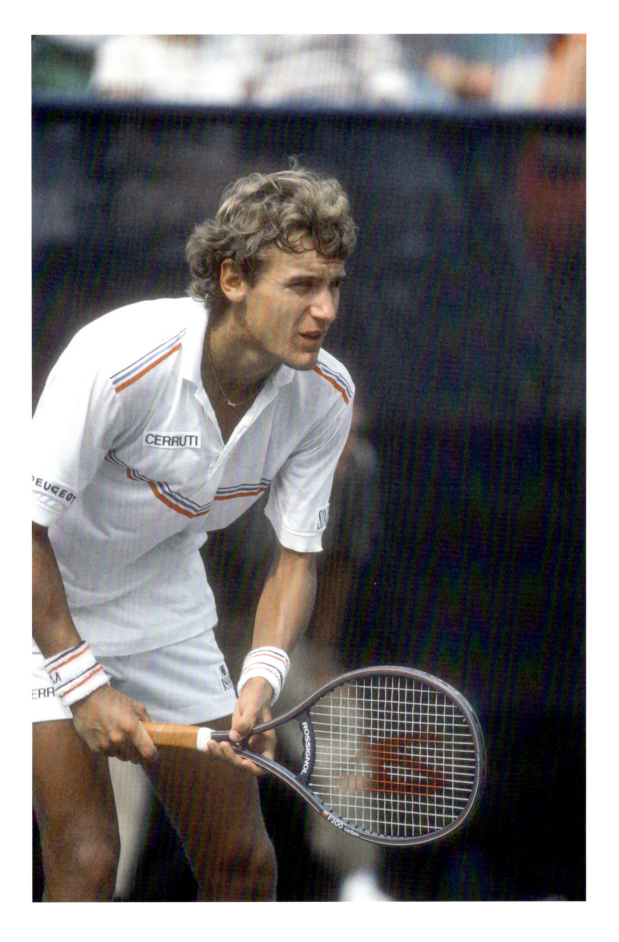

Swede Mats Wilander, former world number one, sported the Cerruti logo through seven Grand Slams.

Winter sport athletes also received the Cerruti treatment. Two-time Olympic gold medalist and slalom and giant slalom champion Ingemar Stenmark wore Cerruti's creations as well.

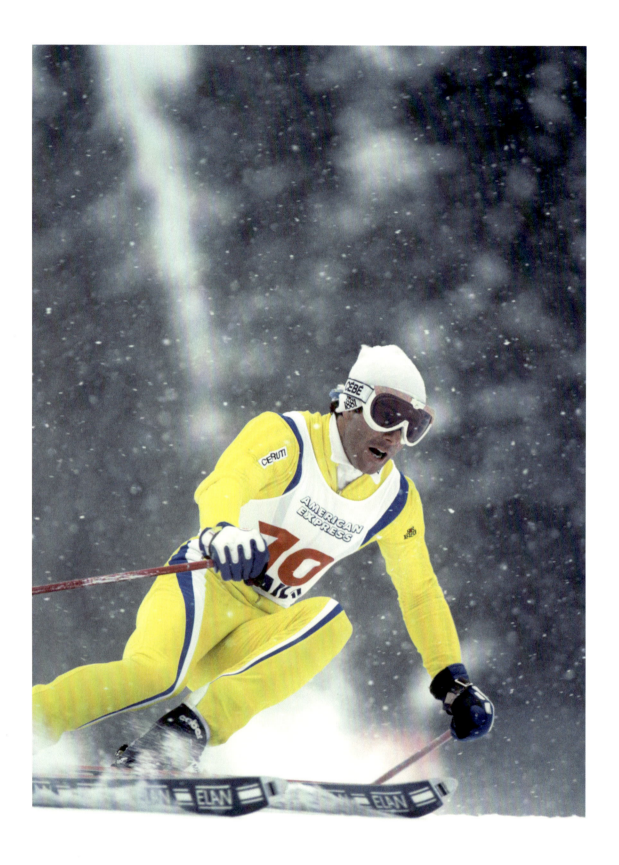

A close-up of a sweater worn by Ingemar Stenmark, now stored in the warehouse of the Cerruti Family in Biella.

Racing Days

In 1994, Cerruti undertook his coolest sporting collaboration yet: Cerruti 1881 became the official outfitter for the Ferrari Formula One team as well as the executives. The team would wear Cerruti clothing while traveling and on the track, with champion racers Eddie Irivine and Michael Schumacher regularly photographed wearing the Cerruti logo. Saying the Nineties were a hot streak for Cerruti is an understatement.

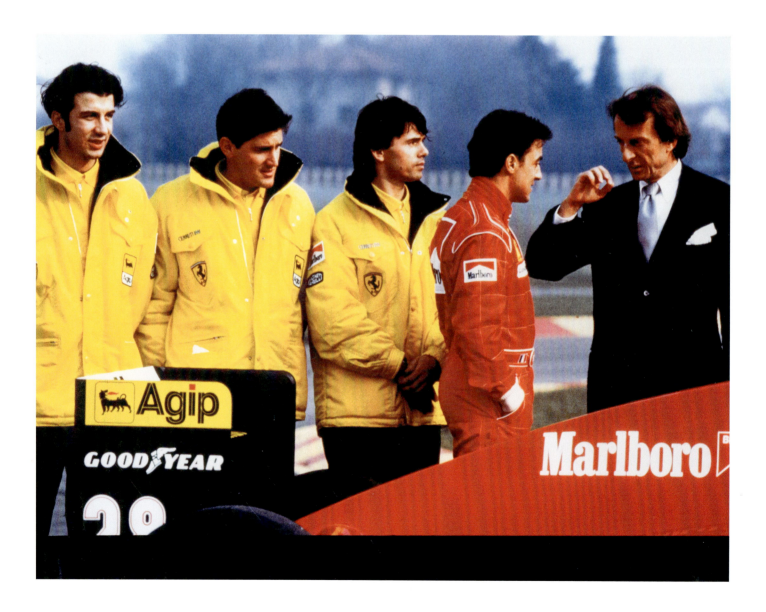

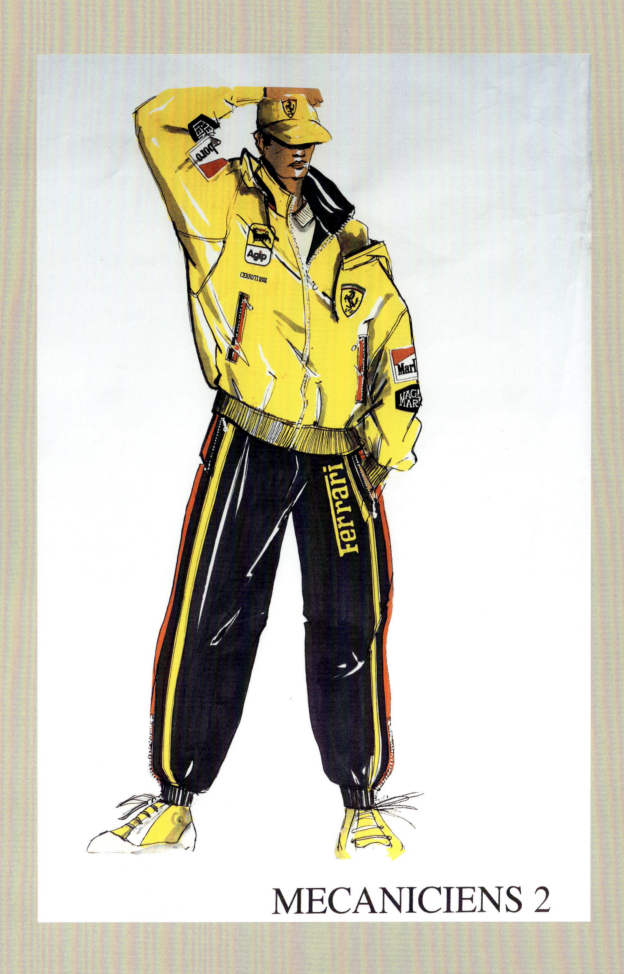

MECANICIENS 2

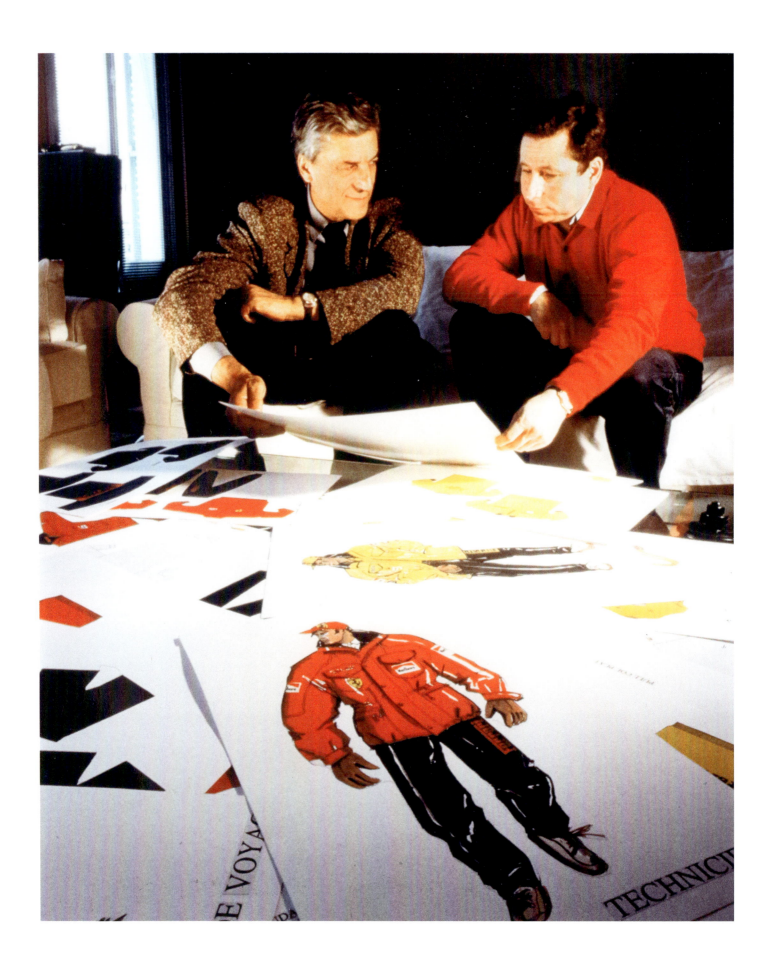

Previous page:
At left, the Ferrari Formula 1 Team with driver Jean Alesi and Luca Cordero di Montezemolo, the president of Ferrari, 1994. At right, sketches for new Ferrari Formula 1 Team suiting, 1994

Opposite page:
Cerruti sitting with Ferrari Formula 1 Team Manager Jean Todt, discussing sketches for an upcoming project, 1994.

At right top and bottom:
Sketches for Ferrari Formula 1 team crew suits and accessories

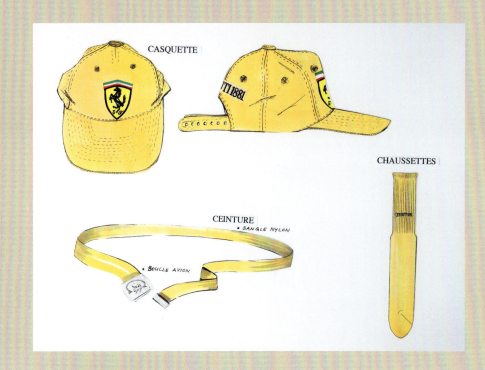

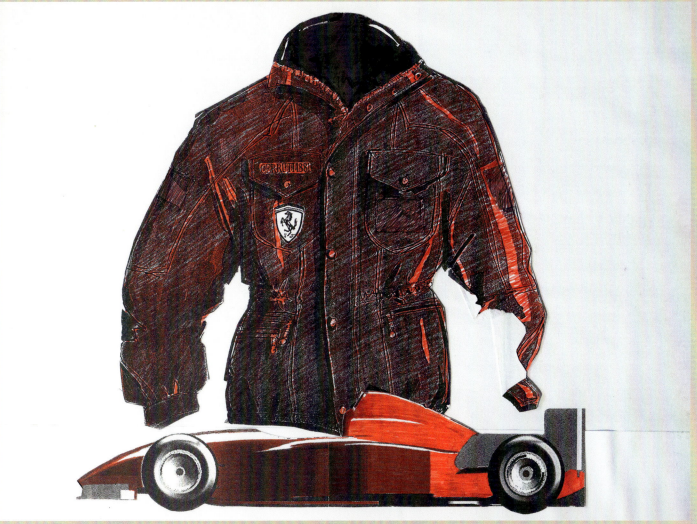

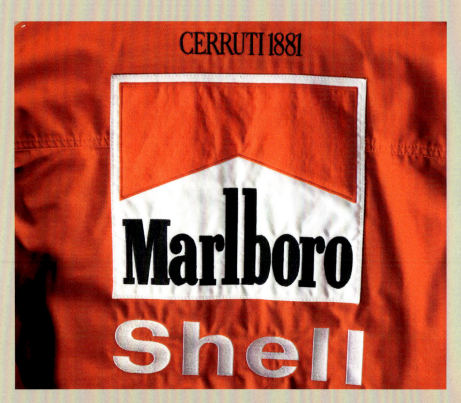

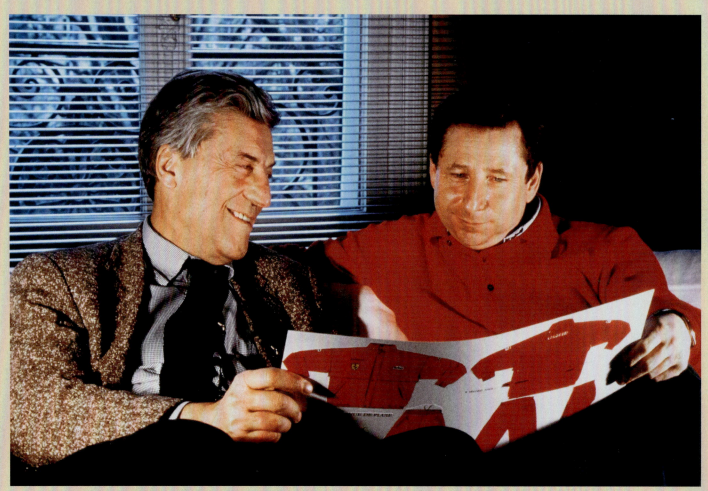

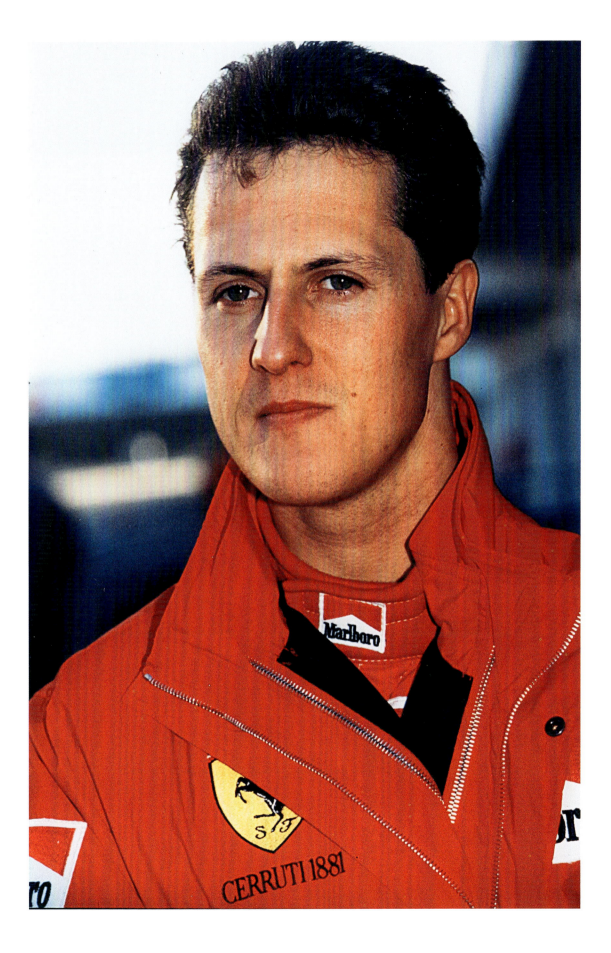

Opposite page, clockwise from top left: Cerruti crew member jackets with logos of Marlboro and Shell co-sponsors; Champion driver Gerhard Berger sporting the Cerruti 1881 T-shirt. Nino Cerruti sitting with Ferrari Formula 1 Team Manager Jean Todt poring over creative

This page: Champion driver Michael Schumacher outfitted in Cerruti

165

Legacy

Nino Cerruti brought a revolution to menswear that was unanticipated in its day but incredibly smart. For 71 years, he captured the spirit of each age with an on-point insouciance. He left an imprint on not just the world of fashion but on the true meaning behind it–why clothes are made and worn in the first place. That may sound elementary, but it was about much more than getting dressed for Cerruti. It was about redefining elegance, for a new, cosmopolitan age that he wanted everyone to play a part in.

In 2001, Cerruti sold his fashion company and stepped back from full-time duties. Although he had energy to burn, the designer made the decision to return to his beloved Biella with his then-partner Sybille Jahr and devote his later years to the mill, taking on a full role and when the operation underwent a sale in 2019, holding a board position. Lanificio Fratelli Cerruti was home, and he was happy to spend the end of his life where it all began. But he couldn't stop creating: From 2001 to 2005, Cerruti created a furniture line called Baleri Italia, done with the designer Renzo Rosso for his company Martin Margiella. It had worldwide distribution and multiple pieces in every category.

From 2010 to 2016, Cerruti's son Julian together with a friend launched an accessories line called Natural Born Elegance. As always, Cerruti was happy to lend his expertise to the next generation, and helped the two promote their new business as well. The name for the line was taken from the slogan of the wool mill, with pieces appropriately crafted solely from Cerruti fabrics. Ties came first, then robes and jackets, all in an enormous range of fabrics and each in a limited series. Natural Born Elegance was sold only online, which cut out the middleman and the brick and mortar and allowed a top product for a fraction of the price.

In his lifetime, Nino Cerruti achieved many awards, among them the Bath Museum of Costume Dress of the Year Award, in 1978; the Munich Fashion Week Award in 1981; the Cutty Sark Award in 1982 and 1988; the Pitti Uomo Award in 1986; the Ordine al merito del lavoro was awarded to Cerruti by the president of Italy in 2000; and GQ Man of the Year Award in 2012.

**Nino Cerruti
in repose,
September 1993**

Today, scientific content dominates the world. This narrows our freedom. Fashion is not scientific, it is fantasy.

— Nino Cerruti

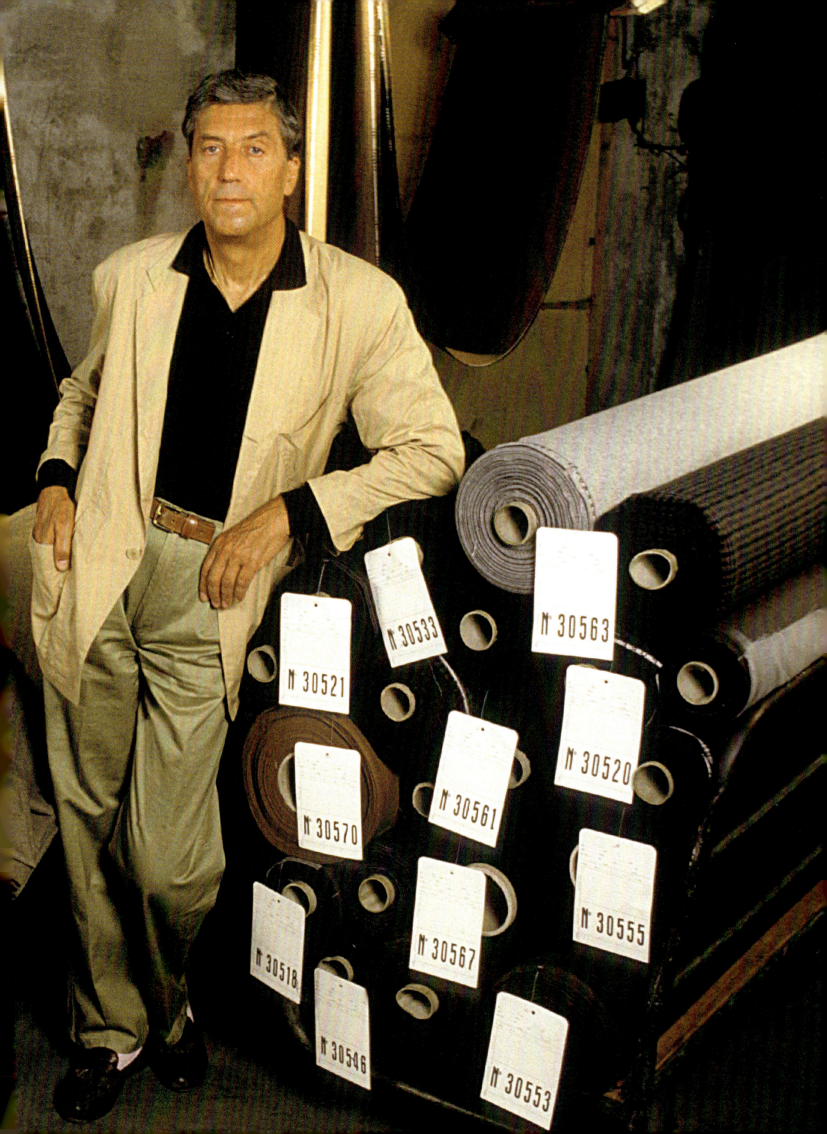

Those closest to Cerruti and those he influenced remember his impact.: "My father changed the way men dressed," says Silvia Cerruti, the designer's daughter. "He really focused on that all his life. It was what he wanted for his legacy, without even knowing it."

Former Cerruti 1881 Creative Director Jean-Paul Knott calls Cerruti a complete master of weaving.
"He was involved in every single step, in every single aspect, in the length of the yarn, the twisting of it. You could see in his eyes the passion for the fabric, the way he touched it. That is what made Nino Cerruti number one for years. He really reinvented the weaving of wool from Biella. There's no other place like it in the world.

And when it came to your designs, he would tell you what he thought was right, and what he thought was wrong, but he was always very respectful and polite. He always wanted to pass along what he had in mind."

Cerruti's contribution to his native Italy has not gone unnoticed: "A giant of Italian entrepreneurship," says Gilberto Pichetto, Deputy Minister of Economic Development and also from Piedmont, of the master adding that he was a significant piece of Biellese history. "I will always remember him with affection and esteem, for his intuitions, competence and foresight with which he made Italian fashion great, exporting our 'Made in Italy' to the world."

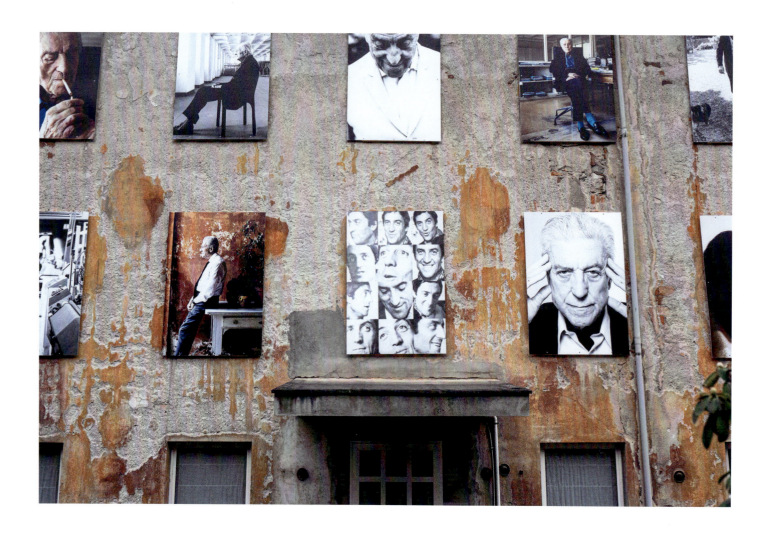

Opposite page:
A Cerrruti tableau adorns the outside of the Lanificio Fratelli Cerruti mill.

At left:
A suiting sketch for men, Fall Ready-to-Wear 1981 Collection

At right: Fashionable 1970s cool in a sketch for the Men's Spring/Summer Ready-to-Wear 1972 Collection

Opposite page: Cerruti takes time out in the south of France.

Francesca Braschi, the Marketing and Communications Specialist at Lanificio Fratelli Cerruti, worked with Cerruti in his last years at the mill: "Every day I had the opportunity to meet the most famous personalities in the fashion world and absorb Signore Nino's unique approach to fabrics: On Monday we were on a video call with the creative director of Dior Man, on Tuesday with a famous *Vogue* journalist, on Wednesday it was the turn of *L'Officiel*, and the following day, he took inspiration from a painting by Klimt to design a new fabric. For Signore Nino, fabrics and fashion were both art, so there were no borders and the dialogue was constant. They were hectic and stimulating weeks in Biella, but connected with the world. In our lives, we are always searching for people who leave a mark, who reveal themselves to be the most challenging, but who remain in our hearts forever. Signor Nino was one of these. Unique, unpredictable, curious, stubborn, courageous, frenetic, difficult, but also affectionate."

"An eclectic man of a thousand nuances. Nino was always about wearable fashion, never fashion for fashion's sake," says Jason Basmajian, a former Cerruti 1881 Creative Director who turned to Cerruti many times for advice. "He was very conscious of what clothes did to the psyche. He just had impeccable taste and integrity, and always knew quality over fickle fashion and fleeting trends." When Basmajian was offered the job at the helm of Cerruti, he rang the designer to get his take. "'It's big shoes to fill', I said, and Mr. Cerruti answered that he thought I had what it took. And when I asked what his biggest piece of advice was, he said, 'Don't get distracted by the fashion system. Always design for you. Stay true to yourself.'"

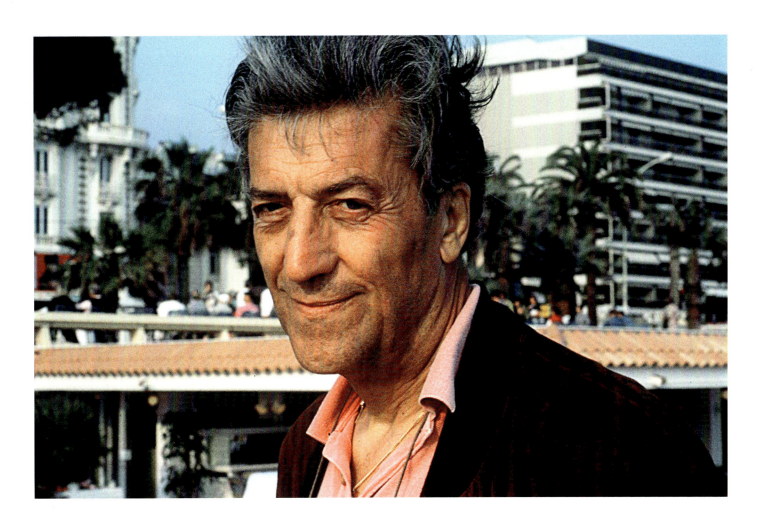

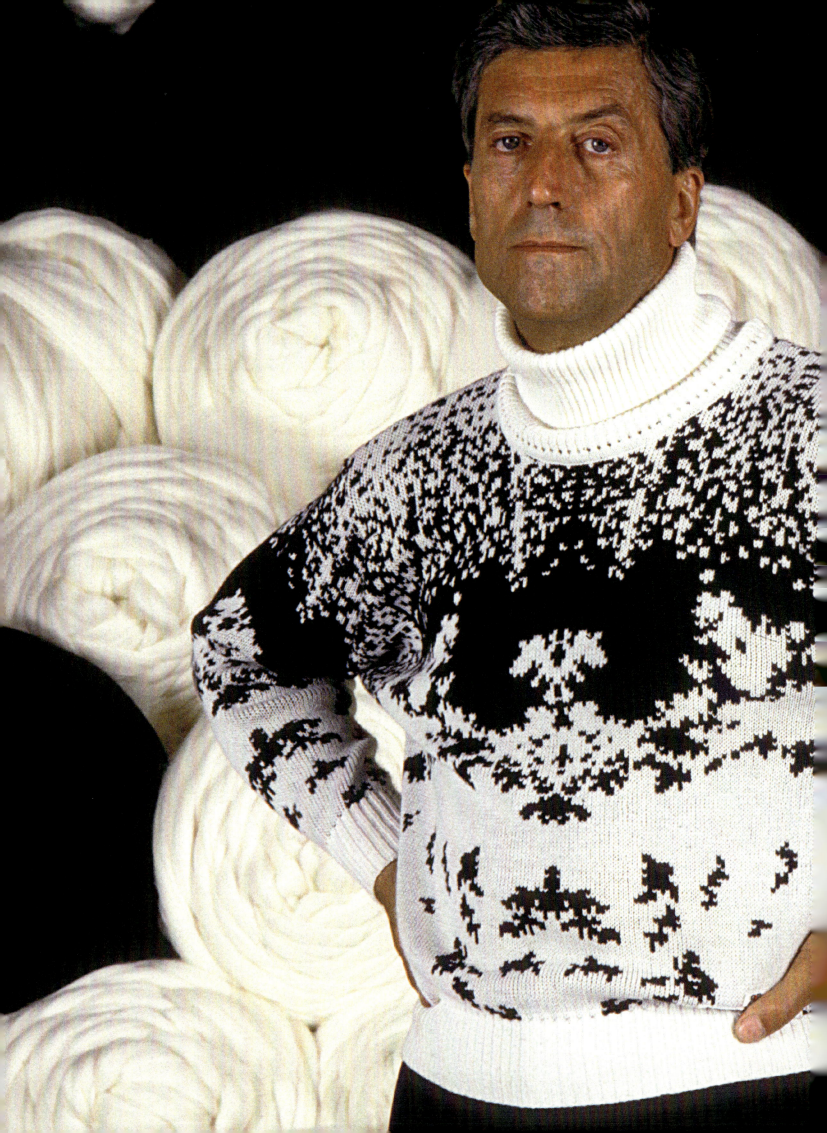

Carlo Capasa, President of the Italian Chamber of Fashion, recalls the great innovator who was one of Italy's chicest men. "He was the first to understand the importance of creativity in menswear, and one of the first to have a strong international presence, representing to the world that unique combination of creativity and quality that came to characterize, and still characterizes, Italian fashion."

Umit Benan, the Milan-based designer, reveres Cerruti. "He's probably the most elegant man I ever met–ever." Benan first came into contact with the elder statesman during his fifth season when a member of the Cerruti team called Benan. "The woman on the phone said to me, 'You know, Mr. Cerruti talks about you all the time and he would like to meet you.'" Benan tells. "So I went to Lanificio to meet him and he was lovely. He took me around the mill and showed me everything–even the archives–and over lunch, he said, 'You know you are my favorite designer over the past years. The way you see fashion is the way I see fashion.'"

In light of his visit, as well as the designer's influence, Benan then went on to design and dedicate a collection for Cerruti called "Third Generation Italians" for Spring/Summer 2012. "I imagined his grandson Oscar at 16, dressed in Nino's clothes, and Nino giving him the keys to the archive. How lucky would Oscar be!"

"I'm just happy to have met him. In my house, I have a photo of my mother, my father, my nieces, and of Nino."

Peter Peliopoulos, Creative Director at Cerruti Arte from mid-1997 to 2002, knows that Cerruti left a mark that went far beyond mere design. "Nino Cerruti was the last of his kind, in many ways. Incredibly chic and handsome with a very authentic style that matched his personality: understated, relaxed, seductive. Mr. Cerruti was a man of his generation, who had a post-war modesty and humility, with heritage and ideas, who like those great Italian industrialists, built something fabulous."

Giorgio Armani remembers Cerruti as one of the people who had a real and positive influence on his life. "From him, I learned not only the taste for sartorial softness but also the importance of a well-rounded vision, as a designer and as an entrepreneur."

"To Nino, fashion counteracted the brutality of life," said his dear friend, actor Peter Coyote. "People in fashion can conflate taste as if it were an ethical matter. Nino wasn't like that at all. He was very serious about it, and he always really cared "Nino embodied this kind of old-world wisdom. I saw him as a model and a way to be with dignity and force. Just going out with him, watching the way he handled everything and everyone, he just did it all so gracefully."

At left and following page: Bolts of fabric and sketches in the Cerruti warehouse in Biella, Italy

Opposite page: A mélange of Cerruti sketches and shots

**Old designs and fabrics,
wrapped for conservation
in the archive of the Cerruti family
in Biella, Italy**

In recounting the history of Italian fashion, its important to remember not only the clothes themselves but also how they were worn.

— Nino Cerruti

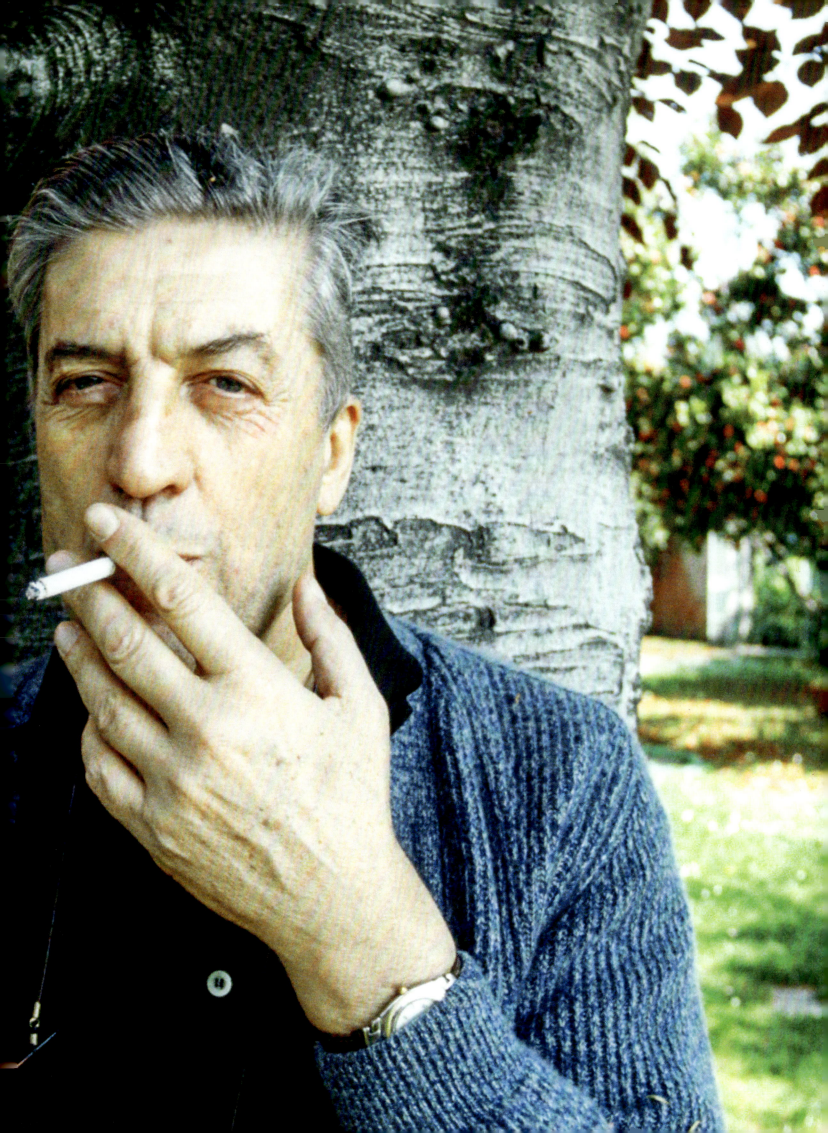

Biography Cindi Cook

Cindi Cook is an author, writer, and editor and is the Paris Correspondent for the international wire service Anadolu Agency. She has served as Editor in Chief of *Hamptons* magazine and her work has appeared in *The New York Times*, *Huffington Post*, *Tatler*, *Allure*, *The New York Post*, *Condé Nast Traveler*, *Hamptons*, *Women's Wear Daily*, and *NYLON*. Ms. Cook is the founder of the women's group Café Femmes and the charity BFF, both based in Paris, France. She is the author of a forthcoming children's book and is at work on a stage play about suburban American life. Ms. Cook makes her home between Paris and Detroit.

Ms. Cook wishes to thank the outstanding editorial team at teNeues for their work on this book, a group effort which made the endeavour a huge success in the end.

Picture Credits

11 © Gianmarco Maraviglia / Courtesy of Cerruti family archive
12/13 © Simone Falcetta
15 © Helen Cathcart
18/19 © Gianmarco Maraviglia / Courtesy of Cerruti family archive
20 © Gianmarco Maraviglia / Courtesy of Cerruti family archive
23 © Gianmarco Maraviglia / Courtesy of Cerruti family archive
24/25 © picture alliance / ZUMAPRESS.com / Giuseppe Pino
26 © Gianmarco Maraviglia / Courtesy of Cerruti family archive
27 © Mondadori Portfolio/Giuseppe Pino
28/29 © Mondadori Portfolio/Giuseppe Pino
30 © Michael Wolf/enapress/SIPA/Shutterstock
31 © Gianmarco Maraviglia / Courtesy of Cerruti family archive
32 © Gianmarco Maraviglia / Courtesy of Cerruti family archive
35 © Michael Wolf/enapress/SIPA/Shutterstock
36/37 © Gianmarco Maraviglia / Courtesy of Cerruti family archive
38 © Gianmarco Maraviglia / Courtesy of Cerruti family archive
39 © Gianmarco Maraviglia / Courtesy of Cerruti family archive
40/41 © Federico Ranghino / EyeEm / Getty Images
42 © picture alliance / Arkivi/akpool GmbH
43 © Gianmarco Maraviglia
44/45 © Mondadori Portfolio/Giorgio Lotti
46/47 © Julian Cerruti
48 © Julian Cerruti
49 © Julian Cerruti
50 © Gianmarco Maraviglia / Courtesy of Cerruti family archive
51 © Gianmarco Maraviglia / Courtesy of Cerruti family archive
52/53 © Julian Cerruti
54/55 © Julian Cerruti
56 © Julian Cerruti
57 © Julian Cerruti
59 © Gianmarco Maraviglia / Courtesy of Cerruti family archive
60 © Gianmarco Maraviglia / Courtesy of Cerruti family archive
62 © Gianmarco Maraviglia / Courtesy of Cerruti family archive
64 © Gianmarco Maraviglia / Courtesy of Cerruti family archive
65 © Gianmarco Maraviglia / Courtesy of Cerruti family archive
66 © Gianmarco Maraviglia / Courtesy of Cerruti family archive
68 © Gianmarco Maraviglia / Courtesy of Cerruti family archive
69 © Gianmarco Maraviglia / Courtesy of Cerruti family archive
70 © Gianmarco Maraviglia / Courtesy of Cerruti family archive
71 © Gianmarco Maraviglia / Courtesy of Cerruti family archive
73 © Gianmarco Maraviglia / Courtesy of Cerruti family archive
74 © Gianmarco Maraviglia / Courtesy of Cerruti family archive
75 © Gianmarco Maraviglia / Courtesy of Cerruti family archive
76/77 © Gianmarco Maraviglia / Courtesy of Cerruti family archive
78 © Gianmarco Maraviglia / Courtesy of Cerruti family archive
79 © Gianmarco Maraviglia / Courtesy of Cerruti family archive
80/81 © Raphael GAILLARDE / Getty Images
82 © Gianmarco Maraviglia / Courtesy of Cerruti family archive
83 © Gianmarco Maraviglia / Courtesy of Cerruti family archive
84/85 © Gianmarco Maraviglia / Courtesy of Cerruti family archive
87 © Gianmarco Maraviglia / Courtesy of Cerruti family archive
89 © Gianmarco Maraviglia / Courtesy of Cerruti family archive
90 © Slim Aarons / Getty Images
91 © Gianmarco Maraviglia / Courtesy of Cerruti family archive
92 © Chris Barham/ANL/Shutterstock
93 © Gianmarco Maraviglia / Courtesy of Cerruti family archive
94 © Denis Pekov / Shutterstock
96 © Gianmarco Maraviglia / Courtesy of Cerruti family archive
97 © Daniel SIMON / Getty Images
98 © Gianmarco Maraviglia / Courtesy of Cerruti family archive
99 © Gianmarco Maraviglia / Courtesy of Cerruti family archive
101 © Daniel SIMON / Getty Images
103 © Gianmarco Maraviglia / Courtesy of Cerruti family archive
105 © Daniel Simon / Getty Images
106 © Daniel Simon / Getty Images
107 © Gianmarco Maraviglia / Courtesy of Cerruti family archive
108 © Daniel Simon / Getty Images
109 © Daniel Simon / Getty Images

110 © Gianmarco Maraviglia / Courtesy of Cerruti family archive
111 © Gianmarco Maraviglia / Courtesy of Cerruti family archive
112 © Gianmarco Maraviglia / Courtesy of Cerruti family archive
113 © William Stevens / Getty Images
114 © Gianmarco Maraviglia / Courtesy of Cerruti family archive
115 © Daniel Simon / Getty Images
116/117 © William Stevens / Getty Images
118 © Daniel Simon / Getty Images
119 © Michel Euler/AP/Shutterstock
120 © picture alliance / PictureLux/The Hollywood Archive / HA
122/123 © Sunset Boulevard / Getty Images
124 © picture alliance / United Archives
126/127 © picture alliance / Mary Evans Picture Library
128 © Raphael Gaillard / Getty Images
129 © picture alliance / PictureLux/The Hollywood Archive / American Pictorial Collection
130/131 © picture alliance/United Archives / IFTN
132 © picture-alliance / Mary Evans Picture Library
134/135 © picture alliance/United Archives
136 © picture-alliance / Mary Evans Picture Library
137 © Sunset Boulevard / Corbis Historical / Getty Images
138 / 139 © picture alliance/United Archives / IFTN
140 © picture alliance
141 © picture alliance/United Archives / kpa Publicity
142 © Paolo Roversi
143 © unknown / The publisher made every effort to find the copyright owner of the image and invites him/her to contact teNeues
145 © Eric Robert / Sygma / Getty Images
146 © picture alliance / ZUMAPRESS.com / Pino Granata
147 © picture alliance / Everett Collection
148 top © picture alliance / United Archives/IFTN
148 bottom © picture alliance
150 © Gianmarco Maraviglia / Courtesy of Cerruti family archive

151 © Gianmarco Maraviglia / Courtesy of Cerruti family archive
152 © Pool ARNAL / PAT / Getty Images
153 © Gianmarco Maraviglia / Courtesy of Cerruti family archive
154 © Gianmarco Maraviglia / Courtesy of Cerruti family archive
155 © Patrice Picot / Getty Images
156 © Focus on Sport / Getty Images
157 © Focus on Sport / Getty Images
158 © John Kelly / Getty Images
159 © Gianmarco Maraviglia / Courtesy of Cerruti family archive
160 © Gianmarco Maraviglia / Courtesy of Cerruti family archive
161 © Gianmarco Maraviglia / Courtesy of Cerruti family archive
162 © Gianmarco Maraviglia / Courtesy of Cerruti family archive
163 © Gianmarco Maraviglia / Courtesy of Cerruti family archive
164 © Gianmarco Maraviglia / Courtesy of Cerruti family archive
165 © Gianmarco Maraviglia / Courtesy of Cerruti family archive
166 © Keith Beaty / Toronto Star / Getty Images
168 © julio donoso / Getty Images
170/171 © Raphael Gaillarde / Getty Images
172 © Gianmarco Maraviglia
173 © Gianmarco Maraviglia / Courtesy of Cerruti family archive
174 © Gianmarco Maraviglia / Courtesy of Cerruti family archive
175 © picture-alliance / dpa
176/177 © Raphael Gaillarde / Getty Images
178 © Gianmarco Maraviglia / Courtesy of Cerruti family archive
179 © Gianmarco Maraviglia / Courtesy of Cerruti family archive
180/181 © Gianmarco Maraviglia / Courtesy of Cerruti family archive
182/183 © Gianmarco Maraviglia / Courtesy of Cerruti family archive
185 © Pool ARNAL/GARCIA/PICOT / Getty Images
186/187 © Michael Wolf/enapress/SIPA/Shutterstock
188 © Cindi Cook

Front Cover & back cover © Simone Falcetta

Imprint

First published in 2022 at
teNeues Verlag GmbH
© 2022 teNeues Verlag GmbH

Text: © Cindi Cook. All rights reserved.

Editorial Coordination
by Conrad Gminder, teNeues Verlag
Production by Nele Jansen, teNeues Verlag
Photo Editing, Color Separation
by Jens Grundei, teNeues Verlag
Layout and Design by Anika Lethen

ISBN: 9783961714261
Printed in Slovakia by Neografia
Library of Congress Number: 2022938387

Picture and text rights reserved for all countries. No part of this publication may be reproduced in any manner whatsoever.

While we strive for utmost precision in every detail, we cannot be held responsible for any inaccuracies, neither for any subsequent loss or damage arising.

Every effort has been made by the publisher to contact holders of copyright to obtain permission to reproduce copyrighted material. However, if any permissions have been inadvertently overlooked, teNeues Publishing Group will be pleased to make the necessary and reasonable arrangements at the first opportunity.

Bibliographic information published by the Deutsche Nationalbibliothek: The Deutsche Nationalbibliothek lists this publication in the Deutsche Nationalbibliografie; detailed bibliographic data are available on the Internet at dnb.dnb.de.

Published by teNeues Publishing Group

teNeues Verlag GmbH
Ohmstraße 8a
86199 Augsburg, Germany

Düsseldorf Office
Waldenburger Straße 13
41564 Kaarst, Germany
e-mail: books@teneues.com

Augsburg/München Office
Ohmstraße 8a
86199 Augsburg, Germany
e-mail: books@teneues.com

Berlin Office
Lietzenburger Straße 53
10719 Berlin, Germany
e-mail: books@teneues.com

Press Department Stefan Becht
Phone: +49-152-2874-9508 / +49-6321-97067-97
e-mail: sbecht@teneues.com

teNeues Publishing Company
350 Seventh Avenue, Suite 301
New York, NY 10001, USA
Phone: +1-212-627-9090
Fax: +1-212-627-9511

www.teneues.com

teNeues Publishing Group
Augsburg/München
Berlin
Düsseldorf
London
New York

teNeues